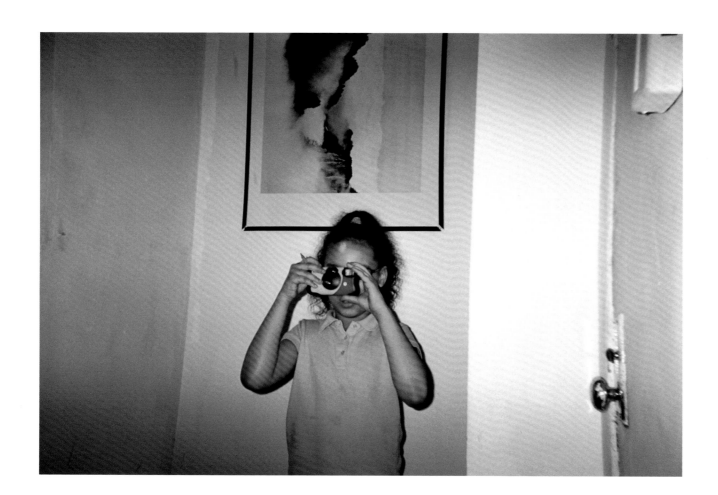

PROJECT LIVES

New York Public Housing Residents Photograph Their World

EDITED BY

GEORGE CARRANO, CHELSEA DAVIS,

AND JONATHAN FISHER

pH powerHouse Books
BROOKLYN, NY

This book combines a selection of participatory photography by New York housing project residents, arranged by the three of us, with a narrative by George and Jonathan.

Our text explains the photography program, after which we examine what brought the projects to their current dismal state, including the very focus of the media on the dark side of project life. We also consider the stakes involved in keeping the projects afloat, pose questions about the projects' future, and explore possible solutions to the problems facing public housing in New York.

We decided to forgo commenting on the particular photos, which would abrogate to ourselves the role properly belonging to the photographers—whose captions evoke their story better than we ever could. Our own role, rather, is to provide the backstory—what happened to public housing in this country, when, how, and why; the "who" not so much—which amplifies every photograph displayed. The remarkable optimism of the imagery should not be taken to mean that living conditions remain manageable for public housing residents. Rather, the joy and determination on display celebrate the remarkable ability of the photographers and their subjects to survive in the face of crime (by a tiny but dangerous minority) and pervasive disrepair, implicitly making the case for improved housing. Pictures and captions are the main event, the narrative merely grounding them in deeper layers of reality.

The product of evenings and weekends away from our day jobs, this book is dedicated to all the talented and inspirational photographers who made this project possible, and in memory of our senior photographers Carolyn Carter, Catalina (Tata) Trinidad, Delverin Jenkins, and Lawrence Wells who are no longer with us, but whose stories and memories live on. You are all in our pantheon.

We would also like to thank everyone who has participated in the makings of this book. Of special note: Hugh Spence, Madeline Rivera, Lily Randall, Jay Tanen, Hillary Altman, Craig Cohen—especially Karen Smul, Will Luckman, Bonnie Briant, and, most of all, David Wilk.

A note about sources: no confidential NYCHA information was used in the preparation of this book. We have naturally called upon our personal experiences with the agency, without ignoring word of mouth heard on the street. Partly reflecting that almost a third of the NYCHA staff reside in the projects themselves, nothing seems to stay under wraps for long, improving the agency's transparency.

We treasure our time spent helping the housing authority, not only by running this project, but among other things by producing videos celebrating some amazing talents who work there—staff who would be a credit to any enterprise on the planet.

— George Carrano, Chelsea Davis, and Jonathan Fisher

THE PROGRAM.

Saturday, 6 p.m., April 2012. Two miles northwest of the Gateway Arch along the rolling Mississippi, a patchwork of prairie and urban forest punctuated most prominently by public schools and piles of refuse delimit the 74 acres where the dynamite brought the buildings down.

About 900 miles to the east, a quarter mile onto Manhattan schist from the equally lordly Hudson, an inquisitive boy, keen of eye with a nine-year-old's shy smile, wanders around standing buildings of identical purpose to those Midwestern ghosts, snapping photo after photo in the fading light of the early spring evening.

Spring 2013
Course Offering

Fall, 2010. Fifteen young and old residents of Harlem's Manhattanville housing project signed up, with varying degrees of trepidation and excitement, for Project Lives, a program the three of us brought to the New York City Housing Authority, or NYCHA (pronounced "NI-CHA"), in conjunction with its 501(c)(3) nonprofit partner, Seeing for Ourselves. Project Lives centered on the use of *participatory photography*: giving people usually on the other side of the lens, in terms of media portrayal, the training and tools to document their own lives with captioned photographs—which NYCHA with its vast outreach could then broadcast. We, native New Yorkers raised in different eras, felt these could create an equally compelling alternate vision of the projects to the degradation portrayed for so long by local tabloids, television, and Hollywood—doing right by half a million low-to-moderate-income Americans who deserve better.

Project Lives (quickly renamed Developing Lives out of current agency sensitivity to the "p-word") featured a free 12-week, hands-on photography course, covering a different facet of picture-taking each week. The participants would put these techniques into practice while dutifully roaming their housing development snapping photos. Equipped with free single-use film cameras donated by Kodak, with their weekly rolls of shot film developed and printed at cost by the world-class Duggal Visual Solutions, the ever more confident students used the projects as their campus, the street as their studio. In today's world, 70 and 10-year-olds find it equally normal to learn from a 20-something, and Project Lives grew. And grew. By the final classes in the spring of 2013, the program had ballooned to serve over 200 kids, preteens, teens, and seniors residing in 15 housing projects.

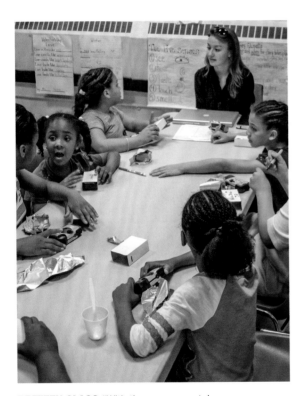

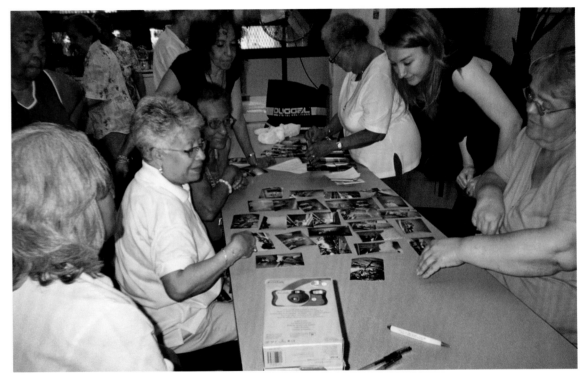

PRETEEN CLASS "With the camera we take pictures of our whole life," confides Rachel, 9. A beguiling grin, "Pictures that are important to us!"

SENIOR CLASS "It opens up new vistas," Barbara, an amateur visual artist herself, applauds. Classmate Vivian tells Chelsea, "The program is delightful."

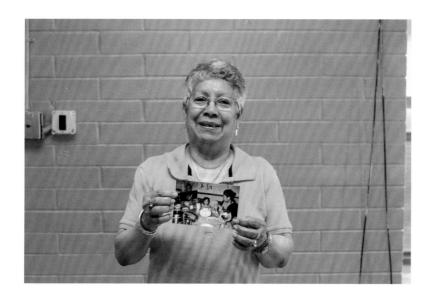

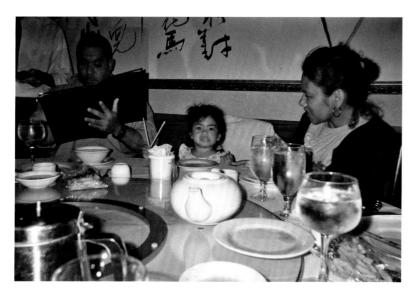

MARCY MORALES, 72, PHOTOGRAPHER

I have been living in public housing for 30-something years.

There are a lot of people that talk about things like, "Oh, you were raised in housing," but it's not where you are being raised, it's the way that you raise your kids, right? I raised four of them all by myself in the city housing, and no problem. I kept them upstairs with me, and I took them to the park when they were small, and I took them to the movies and a show. They are good kids.

One daughter has worked as a hairdresser; my other daughter has her own photography business. My youngest son is 47 now and works in the United Nations. My other son is a soldier.

It's not that because you live in New York City housing, you are a bad person. No, you don't have to be wild, you don't have to be a bad person.

I used to work in the VA hospital, before that I worked in a welfare center. In the hospital, I was at the front desk telling the visitors where to go, and sometimes I worked with the doctors. At the welfare center, I helped with the applications, and I put all the data in the computers.

I am now president of the seniors. I take care of the money, buy the cookies, the coffee, or whatever. And if I have to stop, I'm going to miss it. If they close the center, because they've been closing a lot of centers, then I'm going to need to find somewhere else to go. I'd like to do some volunteering job somewhere. There's a lot of nursing homes around here that need volunteers, and I could go maybe twice a week, or three times a week. I know that I can't stay home, no.

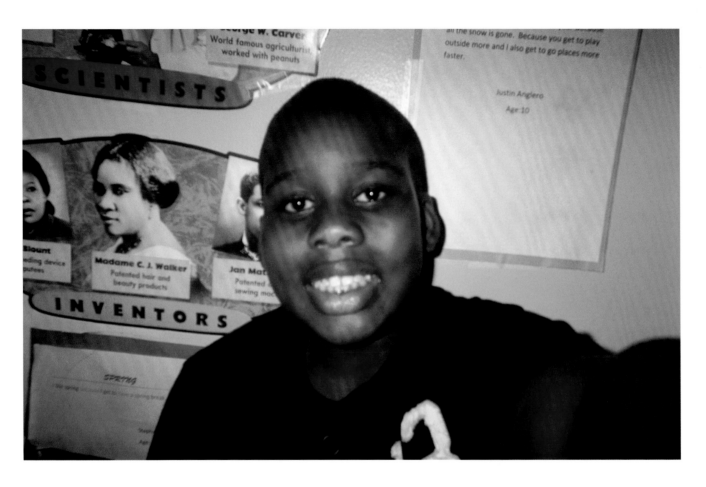

JARED WELLINGTON, 12, PHOTOGRAPHER

I try to find myself in my photos. I try to show how I see my friends, family, and neighbors. We have lived in this neighborhood for a long time.

My mom used to live here when she was younger, and played on the same basketball courts I play on now.

We have three parks right around my building, and I always go to play with my friends and cousins. We treat each other like family. Everyday we walk to school together, go to the community center, and roam around.

THE PURPOSE.

The lively youths in the Project Lives program eagerly learned how to take great pictures, though puzzled at first by the disposable film cameras. "Hey, how do I delete the ones I don't want?" Certain oldsters, for their part, embraced a more ambitious agenda, keenly appreciating the opportunity to change public perceptions of their lives in the projects. Understandably, they felt devalued by the exclusive depictions of murderous teen crews and urine-soaked, broken buildings. After all, the vast majority of residents join no gangs, peddle no drugs, and engage in no violence, while demonstrating prideful care for their homes, trying to make a life for themselves as best they can. Their story, too, needs to be told. "We must show that our lives are not like that."

Not even the elder photographers signed up for anything more, yet we came to realize that here was a chance to turn an irony on its head. The tabloid, television, and Hollywood focus on the horrors of the projects in New York and elsewhere led government not to come to the rescue, but to back further away from its historical responsibility for public housing. Could publicizing the human face of the projects bring the government back to the table? Unknowingly, even the younger photographers would shoulder a unique burden: what if, in order to keep your home, you had to change the way you are perceived—not by your landlord, but by the entire country? Talk about having skin in the game.

ACTING OUT HOW SOCIETY VIEWS YOU

A psychological theory suggests that our sense of ourselves is shaped by how society views us. If we are devalued by others, we may begin to devalue ourselves—and act accordingly.

Were we three at all uneasy about our role as outsiders directing this effort? Nine in ten project residents define themselves as minorities, but none of us do. Certain of our family roots may lie in the projects, but none of us would now qualify.

The very process made the issue moot. In the jargon of the day, Project Lives empowers customers. The participants made it plain that who empowered them mattered not at all.

DEFINING YOUR OWN PUBLIC IMAGE

Turning the traditional paradigm on its head, participatory photography lets those who normally serve as the unwitting subjects of the publicity machine become documenters of their own lives, taking charge of their own public narrative.

The movement originated in American efforts two decades ago to improve the health of rural Chinese women who had never owned a camera. But even now, with cameras nearly universal and everyone able to share online, powerful forces far beyond the social position of some population segments control their public visual definition.

The new imagery produced, by those trained and equipped to do so, seems as complex as a novel, showing rather than telling and without pretense, at times reaching artistic heights rivaling those attained by professionals. Photography in general may constitute the one universal language, a democratic channel, capable of revealing the real world through visual storytelling.

GERTRUDE LIVINGSTON, 70, PHOTOGRAPHER

I raised four children in public housing as a single parent. So many people say to me, "You raised three boys in Harlem and they didn't go to jail and they're not on drugs?" My children all have jobs now, two of them work for public housing, one of them is getting her doctorate.

I live in Polo Grounds, and take care of my grandson now. I try to raise him to grow up to be a loving, kind young man. I go to the Senior Center every day for lunch, and to the choir there as well. I look after all the people on my floor who are alone or don't have any family. There is an elderly woman across the hall who needs help washing her hair, and I help her every day. She has no family so we have to look out for her.

As my neighborhood changes I take pictures of what will never be the same. I can remember the day when Harlem looked like me, and talked like me. The aroma on a Saturday was intoxicating. I love Harlem because you can see the warmth of the people as you walk down the streets. I love to see familiar faces and friends. I see the Apollo and the memories fill my mind.

It's sad because most of the young people are not aware of what's going on. They're going to be rubbing their behinds and scratching their heads, like, "What happened?" It's a big change and you see it every day, every day. And something needs to be done, something has to be done or this town is going to be for the super, super rich. The super, super poor, they're going to be in the street.

THE PUBLICITY.

The striking work produced by the Project Lives photographers began to get noticed early on, thanks in part to a new website launched by the agency, studionycha.org, and with the program warmly featured in both the agency's internal newspaper, and a local tabloid that seemed to never have a polite word to say about the agency—and which even then may have been sharpening its teeth for the all-out attack soon to follow. Kodak blogged about the program in 2012. The expansion of Project Lives into video won it a national award for government communications in 2014; the program extensively covered that same year in the academic *Georgetown Journal on Poverty Law & Policy*. Requests to set up similar programs came in from locales as distant as East Belfast in Northern Ireland. The photographers seemed to be satisfying, if not also stimulating, unusual curiosity about life in the New York projects as conveyed by those who live there. But it would clearly take something more—this book, a movie—to begin to achieve the program's true purpose of allowing the reset button to be pressed for support by all levels of government.

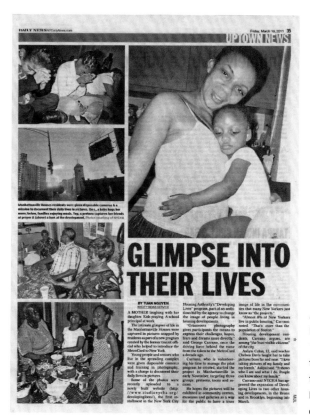

Daily News, March 18, 2011. "An ambitious bid by the agency to change the image of people living in housing developments."

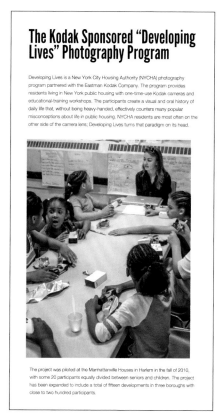

Kodak Blog, December 3, 2012. "The participants create a visual and oral history of daily life that effectively counters many popular misconceptions about life in public housing."

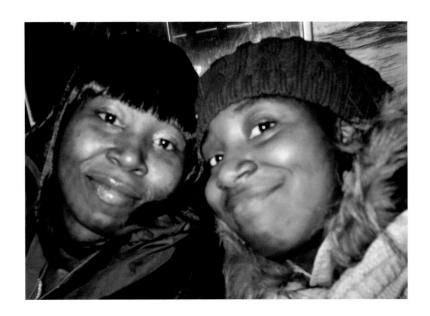 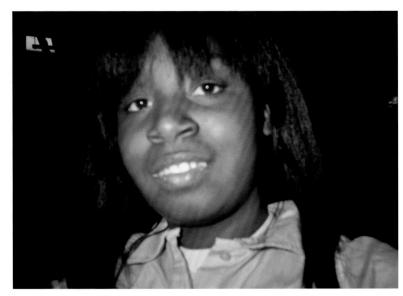

AALIYAH COLON, 11, PHOTOGRAPHER

I've lived in Manhattanville all my life. I love that I can come into the house and someone's always there to open the door for me, and when I'm upset, to give me a nice, warm hug. I live with my brother, my sister, and my mom.

The day that my brother was born, I got to hold him, sitting on the bed, saying, "He's my baby brother, he's my baby brother." Now he's nine. When my sister was three, she told me that she loved me and that she wanted to be a nurse and grow up just like me. Now she's seven.

I play with my friends and all the people that I know, and they always say hi. It makes me feel warm inside. Sometimes we go to each other's houses and it's really fun because we get to spend a lot of time together. We treat each other as if we're family.

In the community center, we have homework time, gym time, and we stay here until six o'clock. My favorite thing about the community center is that all of the people are very well respected. They know how to speak to you. If you're in a bad mood or you don't listen, they try to calm you down. They have a way of talking to you without yelling at you necessarily, like, "Don't do that."

Last week I asked God if he could help me love my enemies for who they are, even though they tease me and bully me, to help me try my hardest to do good in school, and to bless everybody in the community center.

THE PICTURES.

What you see here you view through the eyes of New Yorkers living in the projects.

A determined young girl purposefully striding through her school hallway bundled in her pink winter coat, reveling in the quiet—such quiet she can finally hear herself think.

A silver-haired widow sitting warm and comfy in her old blue sweater, head supported by one arm while catching a basketball game on TV, proud of her granddaughter taking her picture but ashamed of her own worn attire.

A stooped, dutiful husband, apparently pushing 70, filling the narrow kitchen in his Sunday finest, wondering mournfully if just this once he can get out of going to church.

Journey into a world you've never seen, invisible because these images of the New York projects don't have sensationalist appeal. But that doesn't deny them higher powers. As a famous photographer noted half a century ago, the most banal aspects of everyday life can be imbued with compelling drama in the hands of the right picture-taker. What you see here you view not from the vantage point of a reporter routinely dispatched by a tabloid for a few shots enlivening yet another crime story, but through the eyes of New Yorkers living in the city's projects. And so you will make their acquaintance as well.

What do all the photos on the following pages have in common? Optimism, joy, determination, in both the photographers and those portrayed. Anyone living in the New York projects has absorbed much of what life can throw at people. But none of our photographers, not even the seniors lamenting that things used to be better back when, take this opportunity to complain, but rather simply demonstrate pride in their homes and in their lives. As well they should. Indeed, the unhappy tale told later on in this book about what they and hundreds of thousands of other New Yorkers have had to endure may well embarrass them. For this we apologize.

Less of an accusation than a plea for change, their work returns to the oldest of answers.

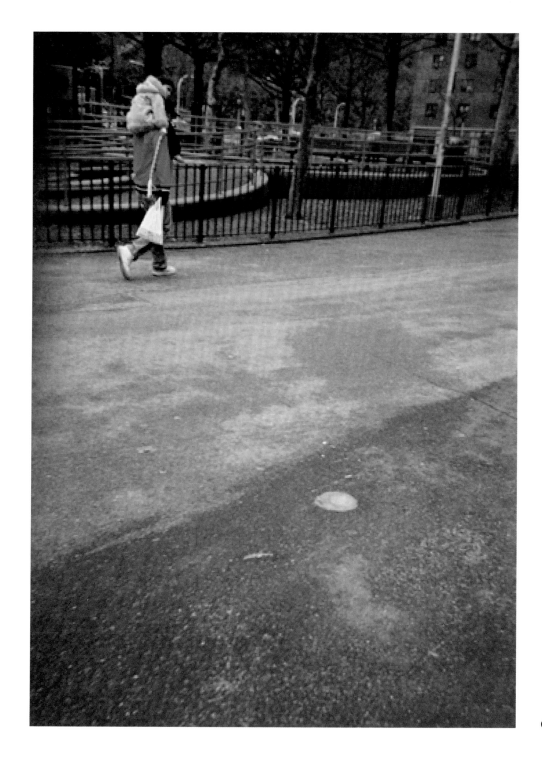

GEORGIA BISHOP

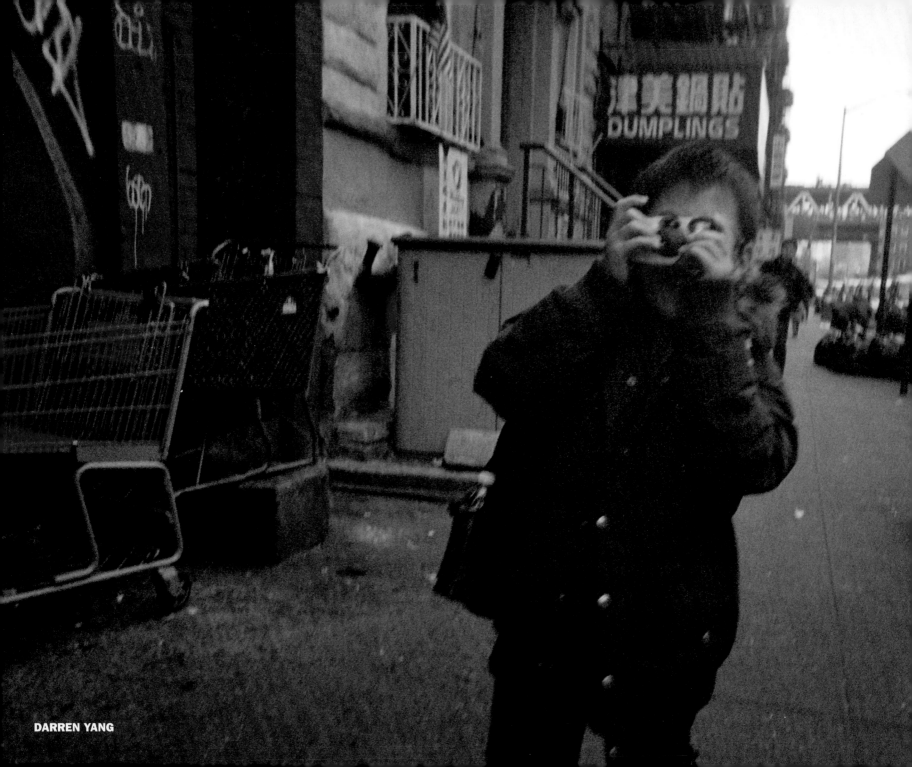

DARREN YANG

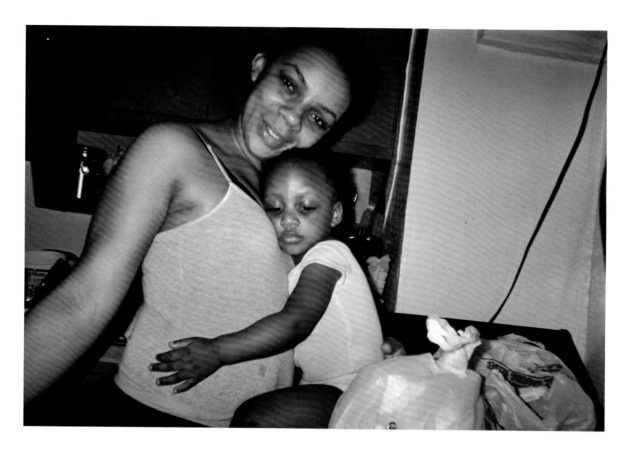

*You should always put your family first. My favorite person in the world
is my mom. I love my mother so much because she is a very strong woman and a great
mother to me, my two sisters, and my brother. We all admire her and respect her.*

— JANYIA FORD

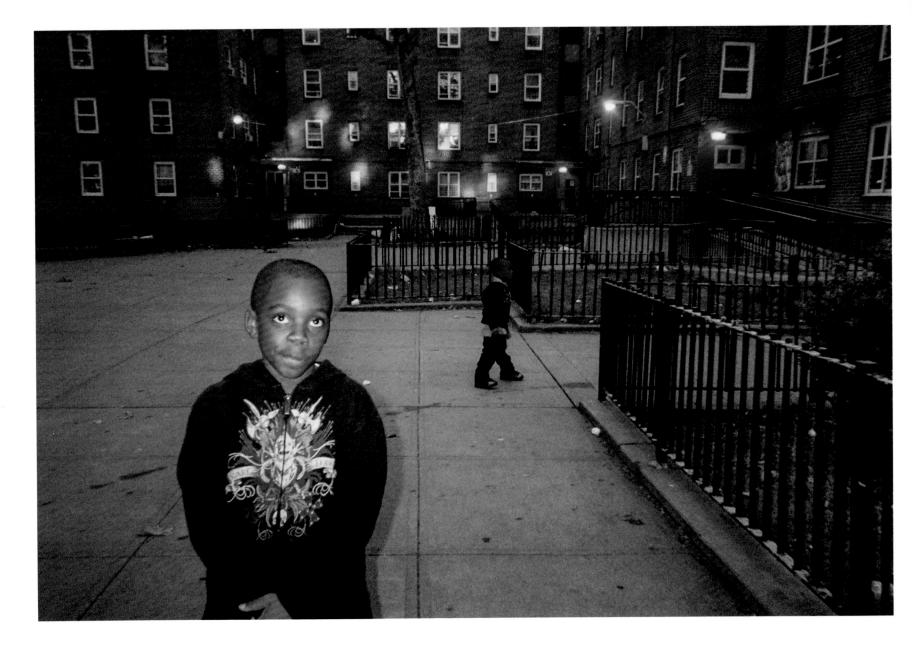

We roam around this spontaneous block sticking together as brothers. Yet we are cousins.

— JARED WELLINGTON

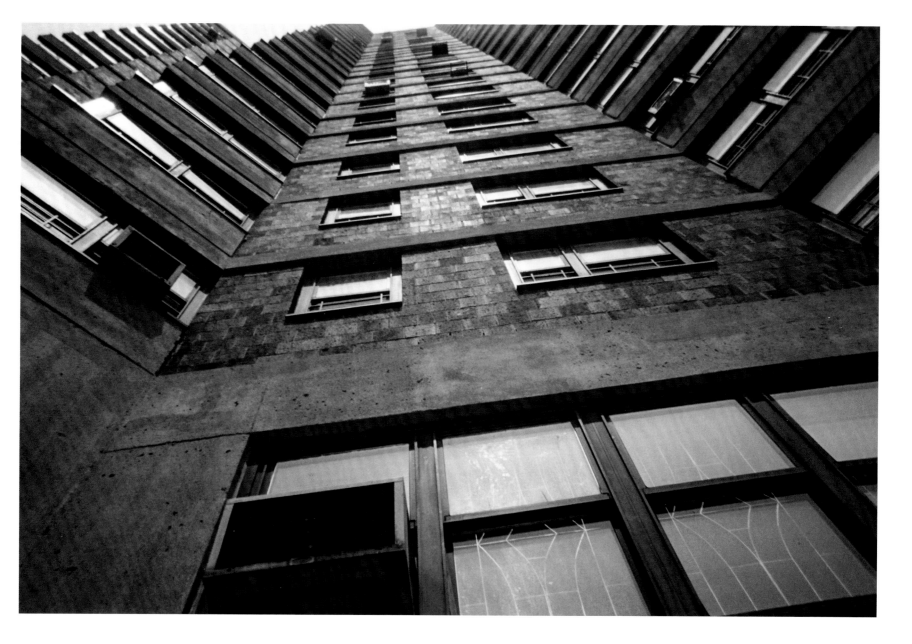

SHALLIYAH ATKINS

MARGARITA CURET

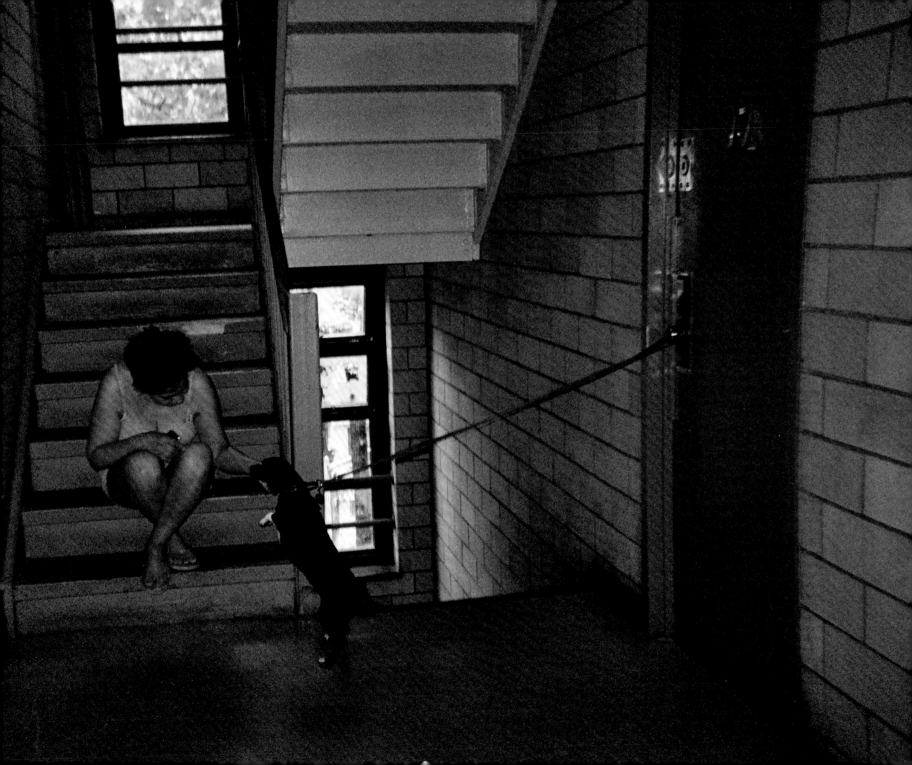

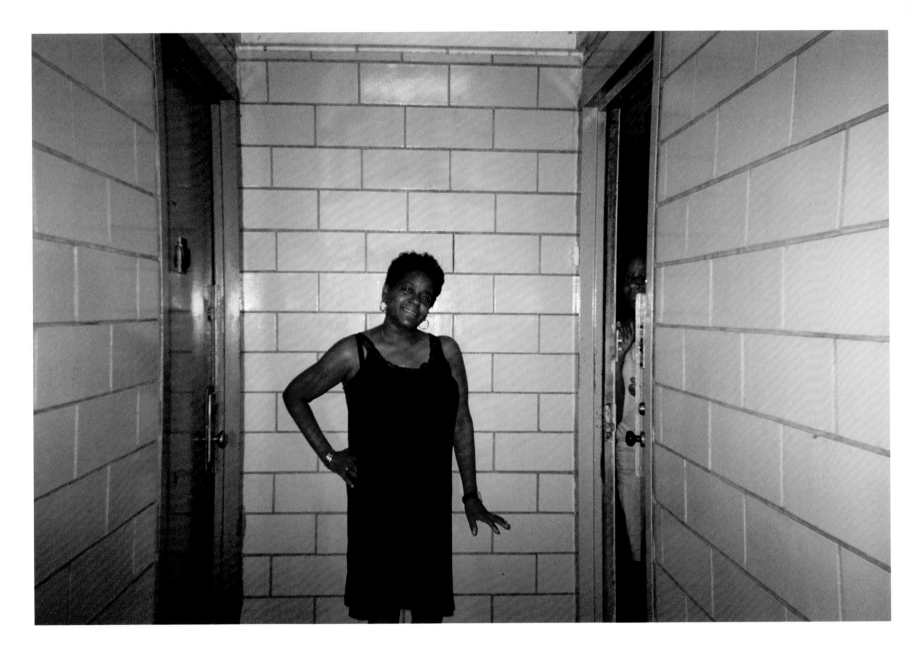

She just got home from a date. Her daughter had the door cracked, looking out.

— MARY REED

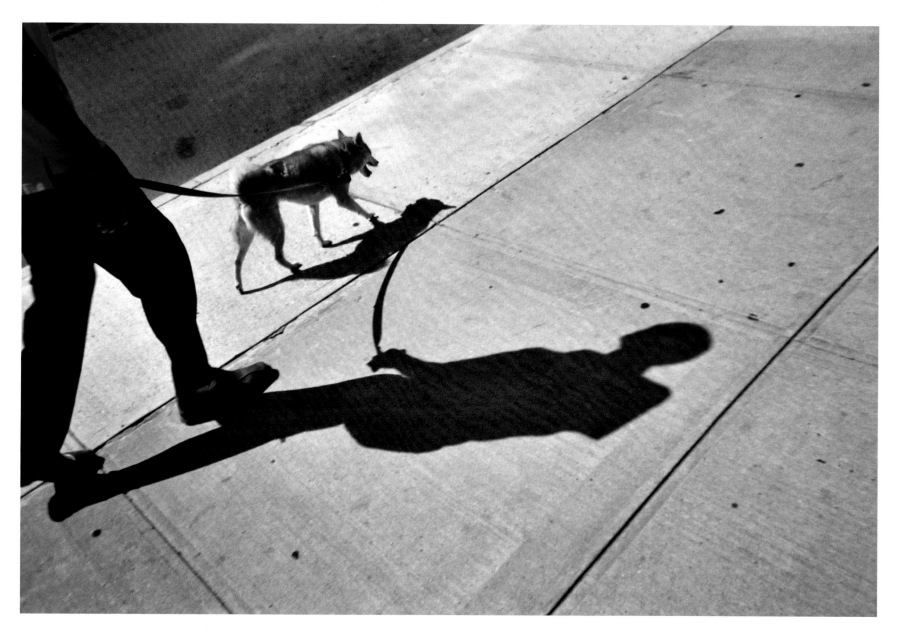

Walking Nico.

— MARGARET WELLS

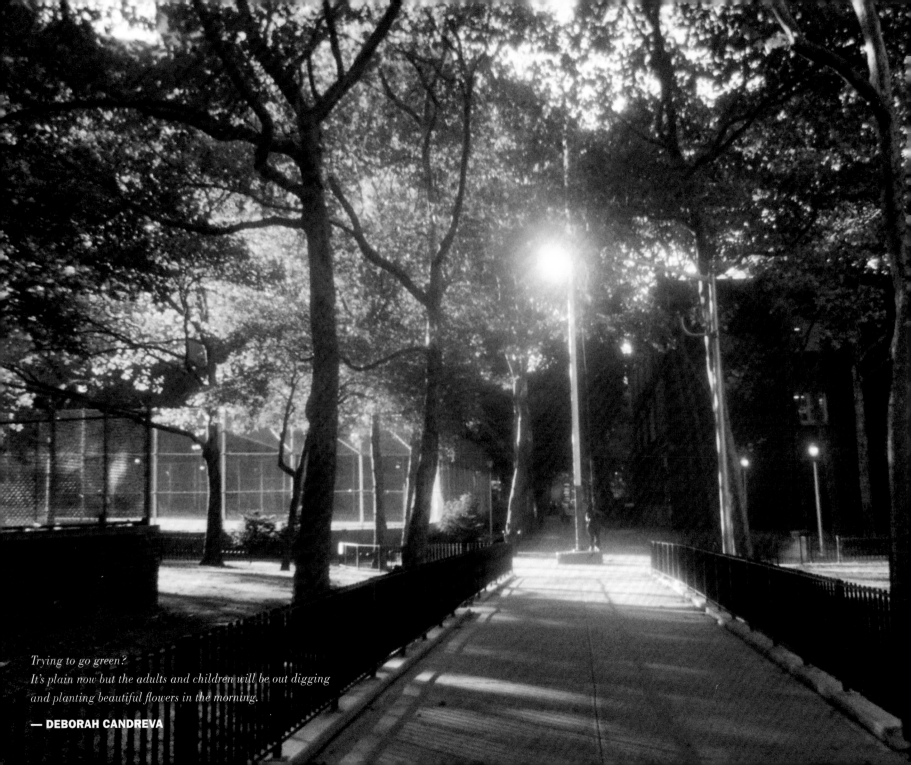

Trying to go green?
It's plain now but the adults and children will be out digging
and planting beautiful flowers in the morning.

— DEBORAH CANDREVA

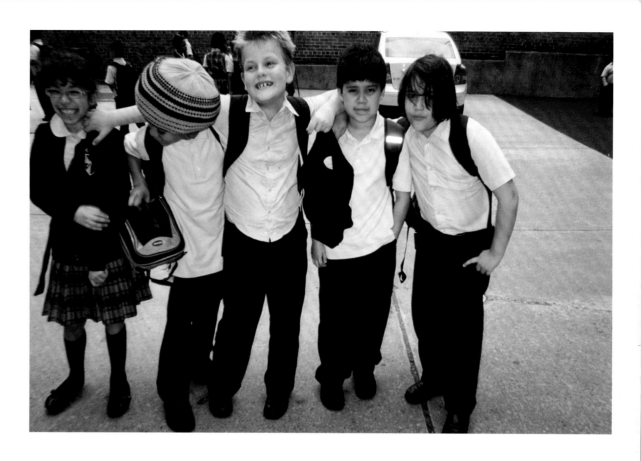

UVICA FRANCOIS

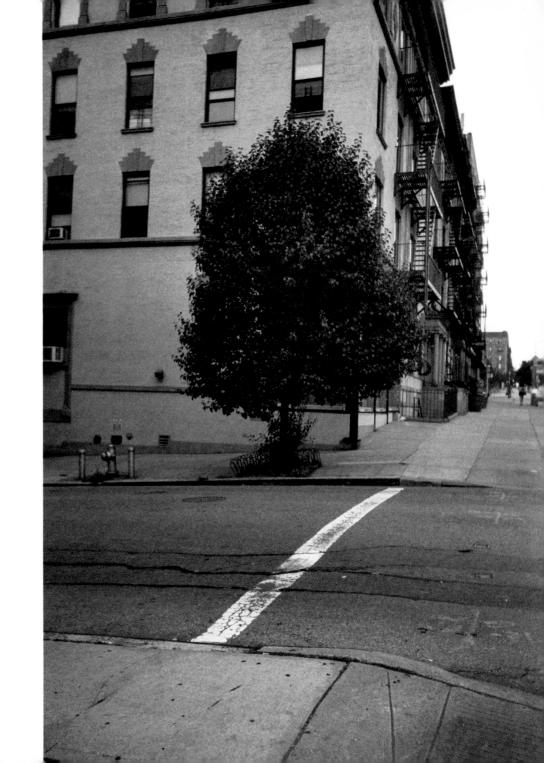

A tree grows in Harlem, on a lonely corner, in all its glory.

— MARGARET WELLS

Do I really have to go to church this morning?

— MARGARET WELLS

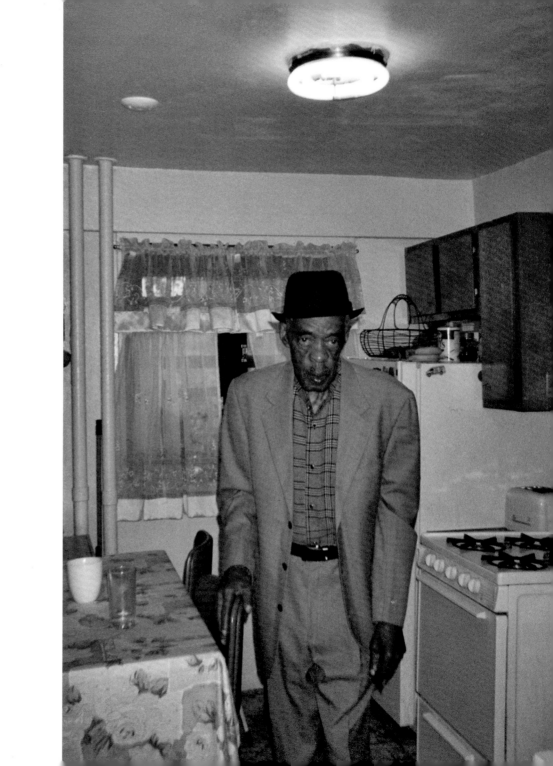

*I have been there ever since I was a baby and it just means
so much to me because almost all my family, like my grandmother,
my dad, my aunts and stuff, live there.*

— AALIYAH COLON

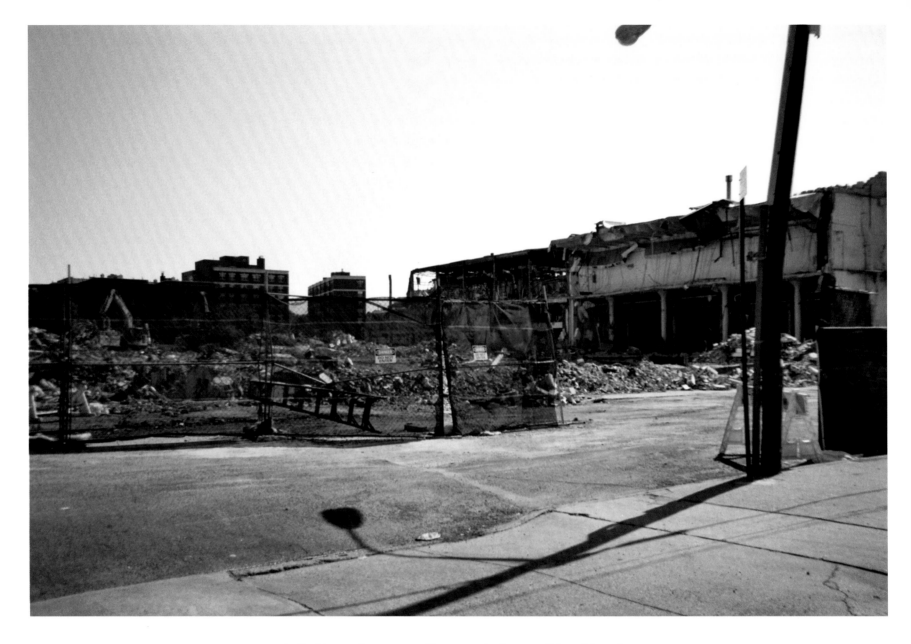

Stella D'oro Bakery, a part of history in the Bronx, will be a BJ's outlet.

— ANA SANJURJO

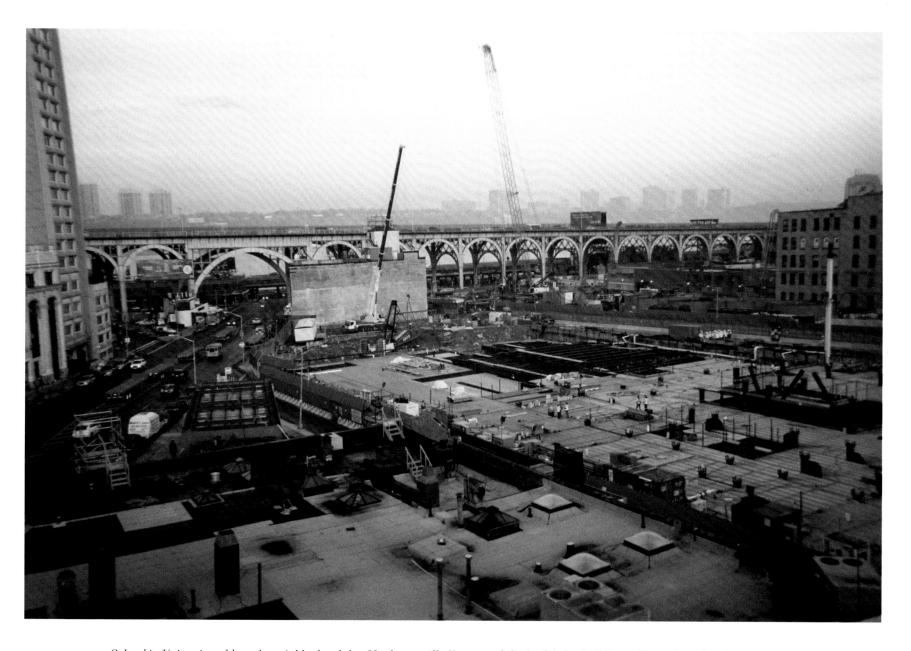

Columbia University adds to the neighborhood, but Manhattanville Houses and the Studebaker building still stand regal in the community.
(Caption by Margaret Wells)

— HELEN MARSHALL

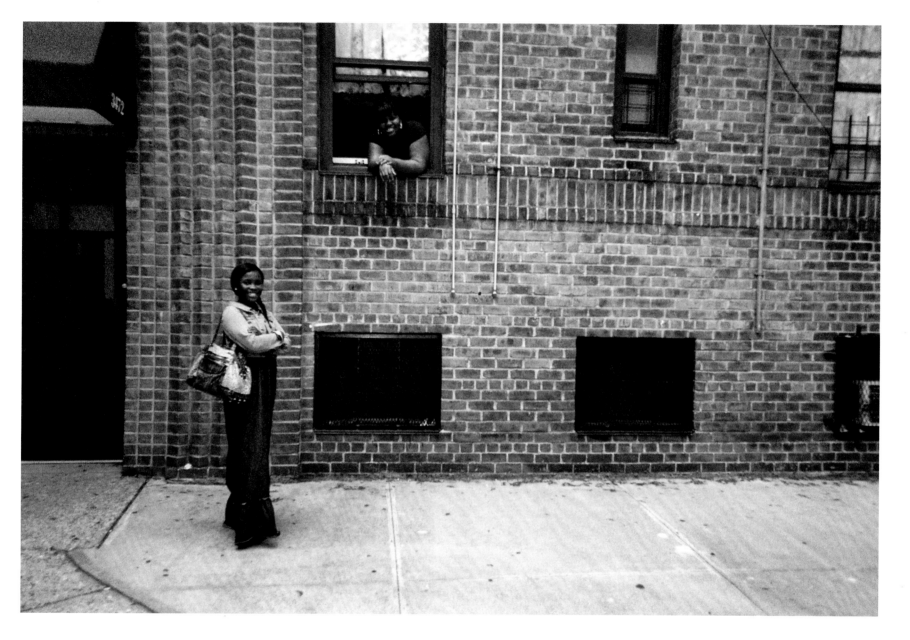

My neighbors.

— JANE MARY SAITER

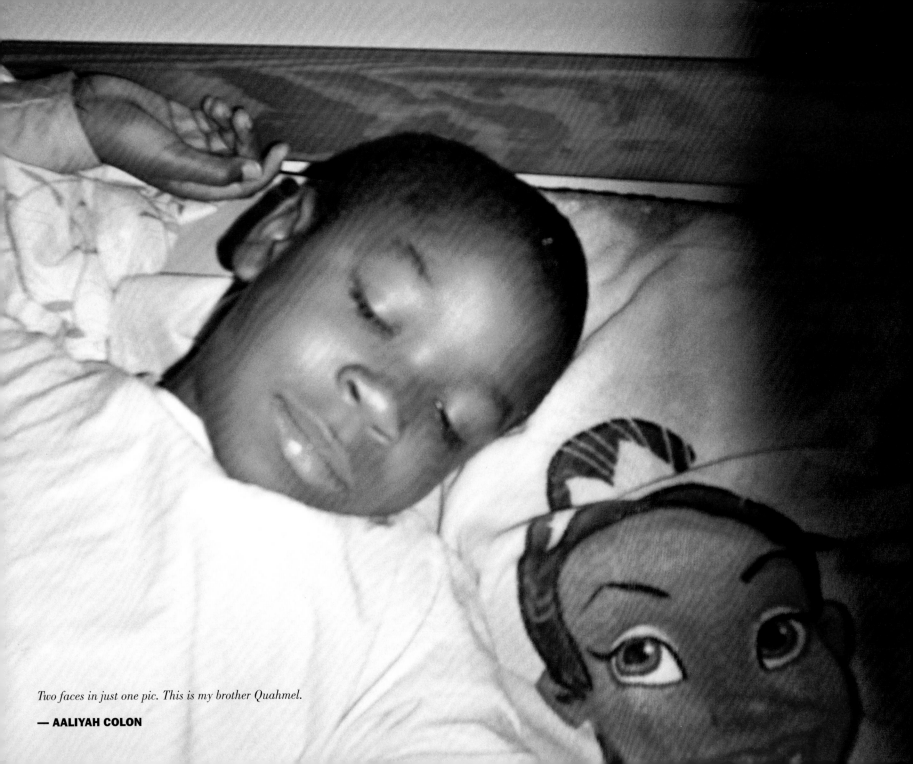

Two faces in just one pic. This is my brother Quahmel.

— AALIYAH COLON

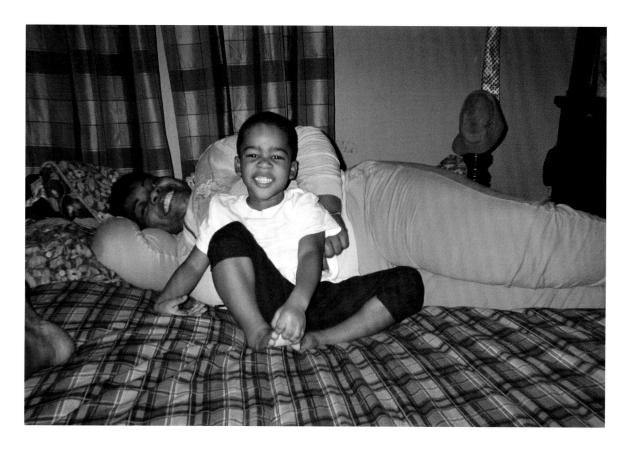

GERTRUDE LIVINGSTON

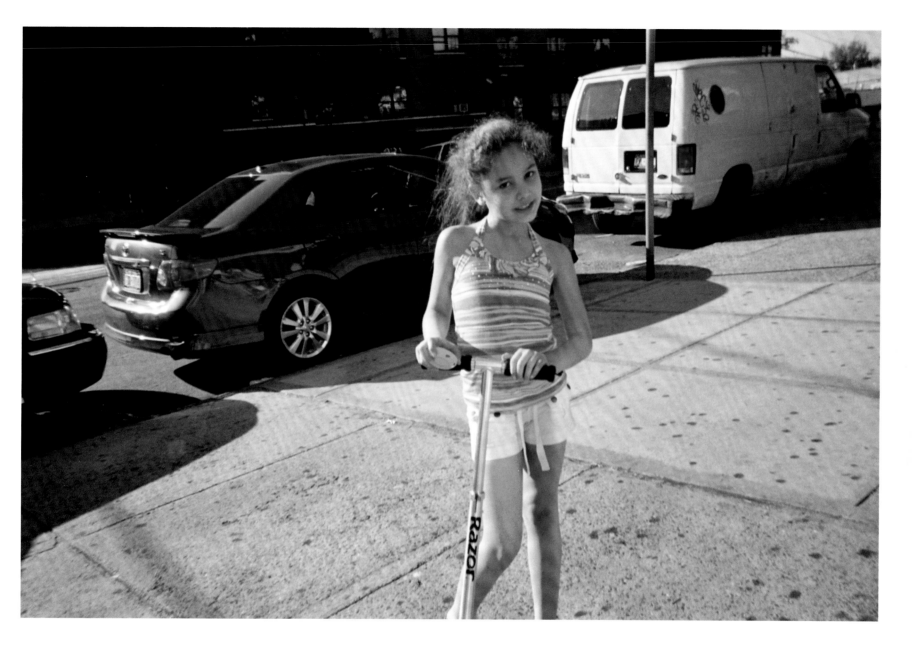

My cousin Alissa likes being bossy because she thinks she is "popeller."

— CHRISTIAN JIMENEZ

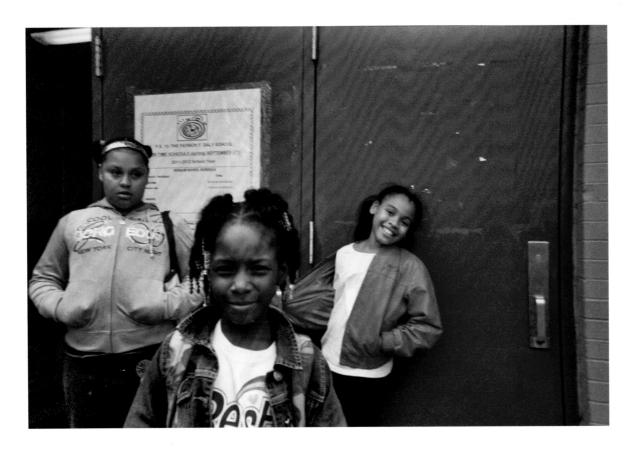

I love living in my neighborhood because I get to hang out with my friends and dance every day. I've been in my
neighborhood all my life. I used to live with my grandma and now I live across the street from her.
There was one girl that I knew for six years. She was my friend. Her name was Ahmya. One day she had to go to a
different home, so I made an "I love you" card, but in the summer we go to visit and I still call her every night.

— ANGELLY SUERO

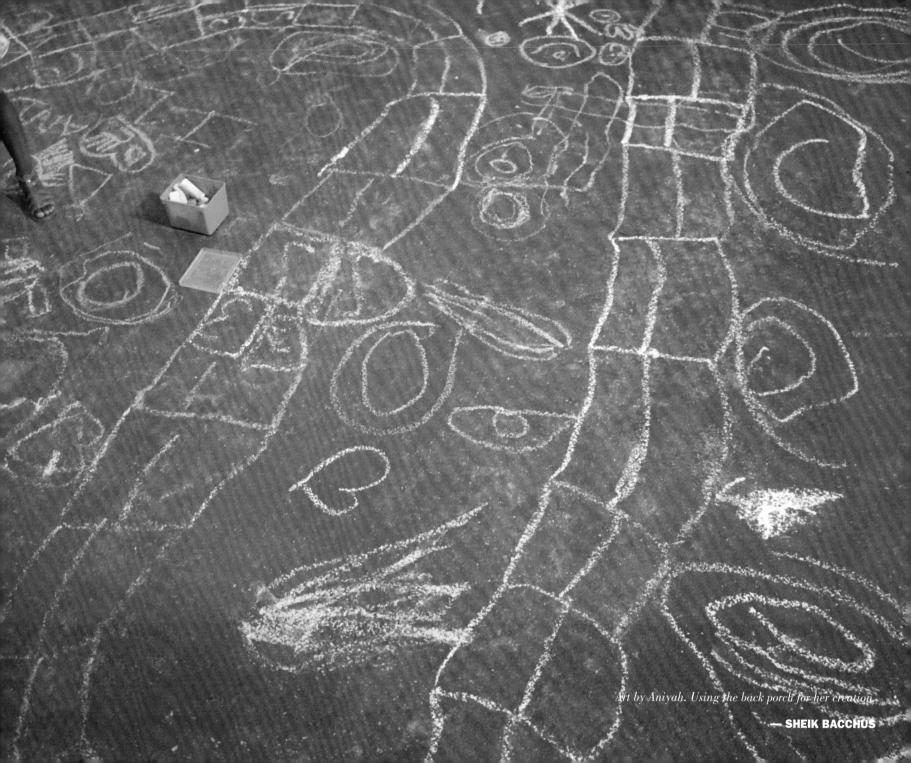

Art by Aniyah. Using the back porch for her creation.

— SHEIK BACCHUS

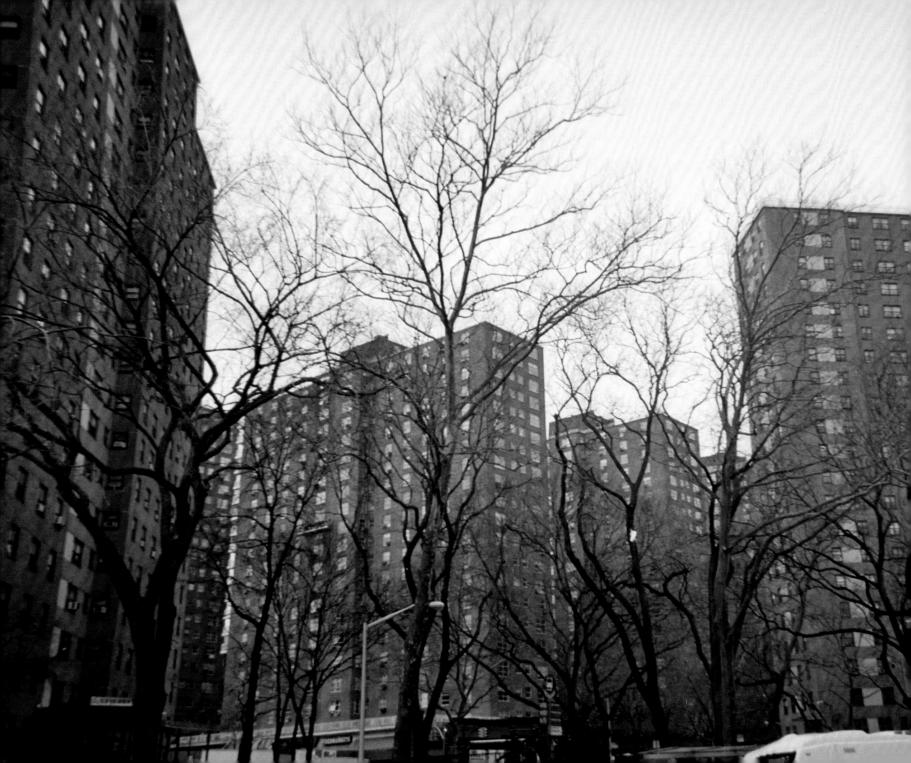

HELEN MARSHALL

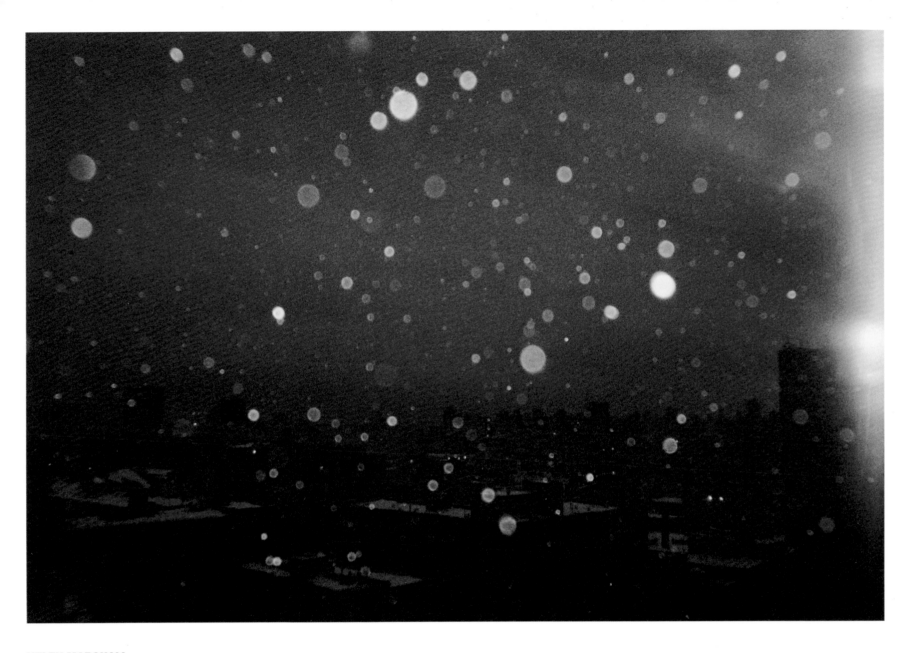

HELEN MARSHALL

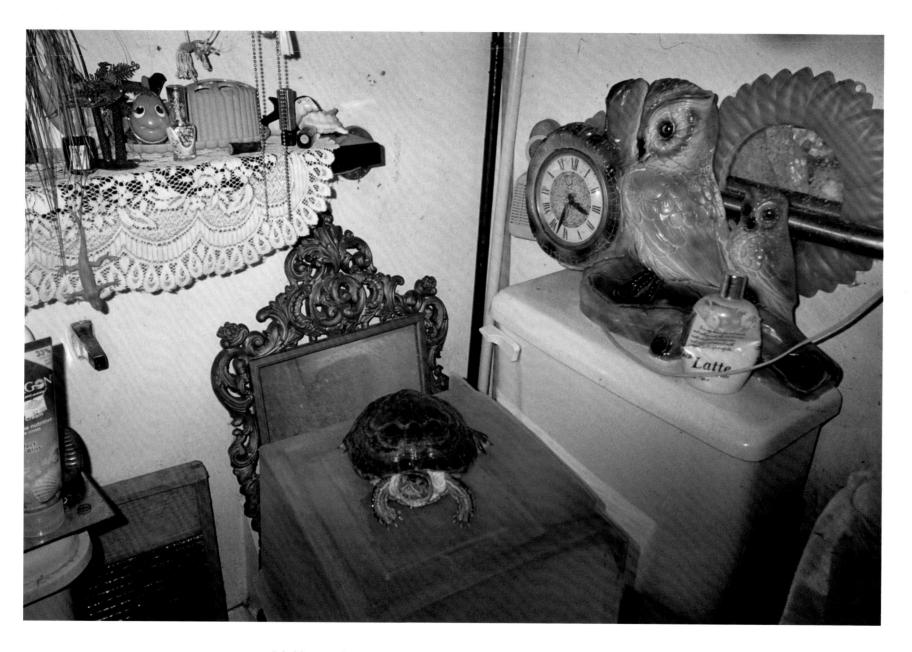

I feel happy when I take pictures of my turtle and I put my turtle in a box.
Be careful you don't fall to the floor, that would hurt!

— SUSANA ORTIZ

On Christmas I photograph my cat and I dance with my cat.
Dance ballerina, because you like the music.
She likes that I dance and I feel content. She is as happy as a person. I love my cat.

— SUSANA ORTIZ

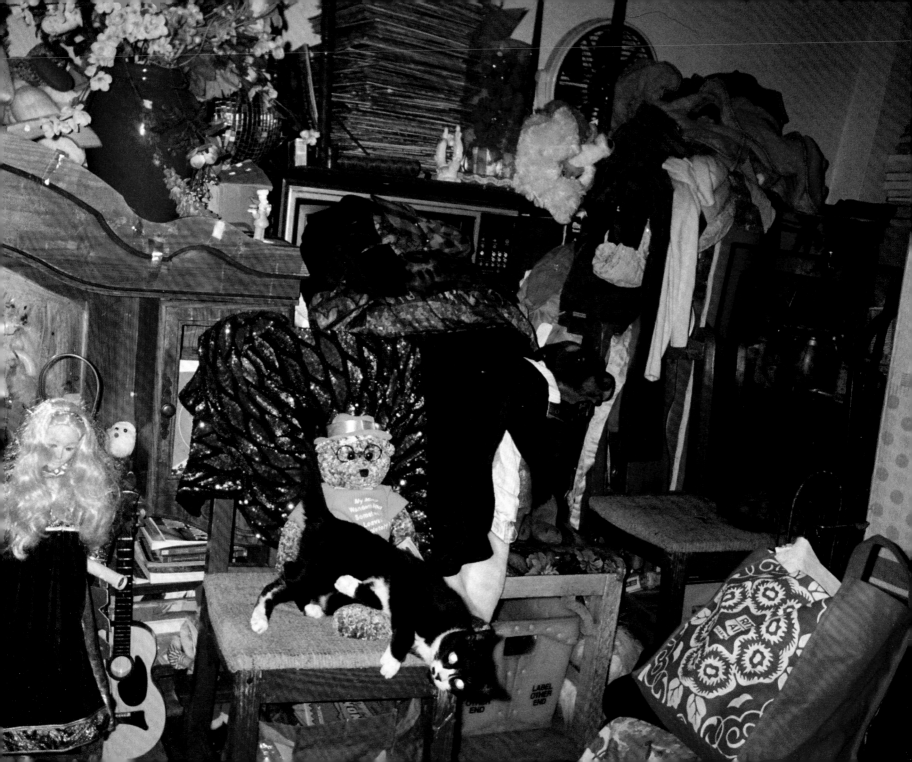

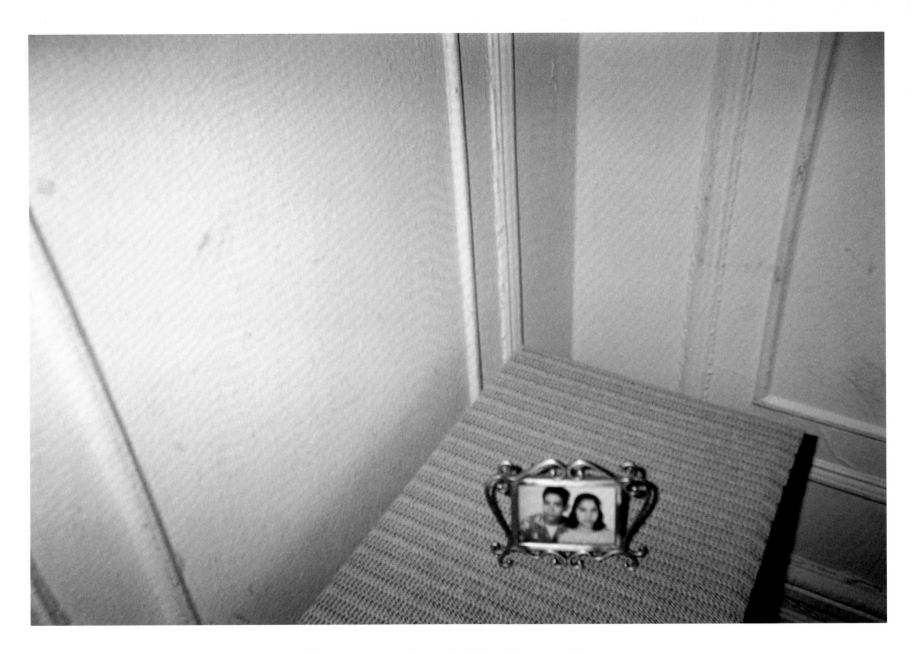

Mi esposo y yo antes de casados el tiene 20 anos y yo 16 anos.
(My husband and I before we were married, he is 20 and I am 16.)

— ALINA NAVARRO

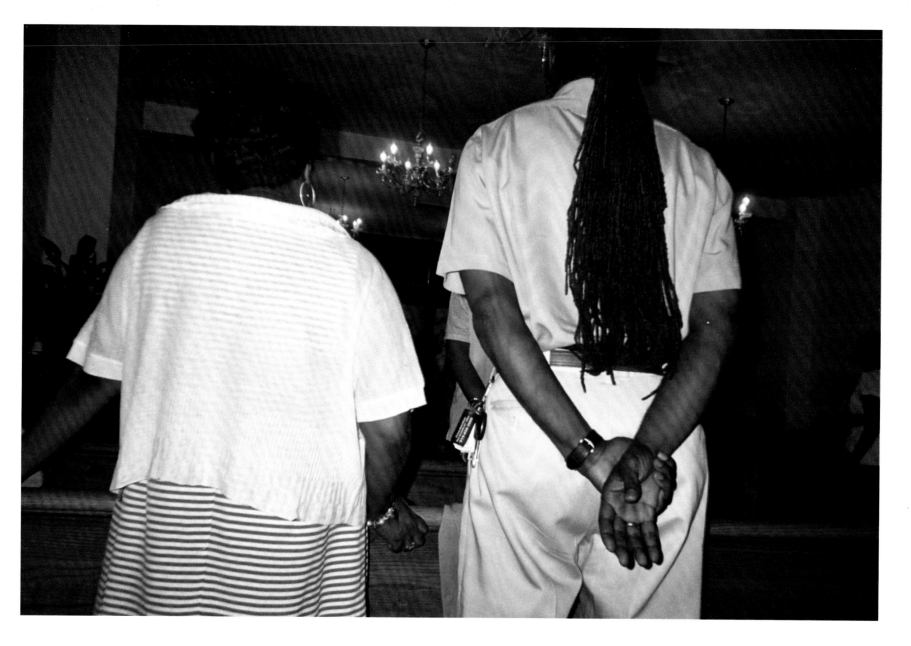

Pray for us, we're getting married tomorrow.

— DOROTHY BALLARD

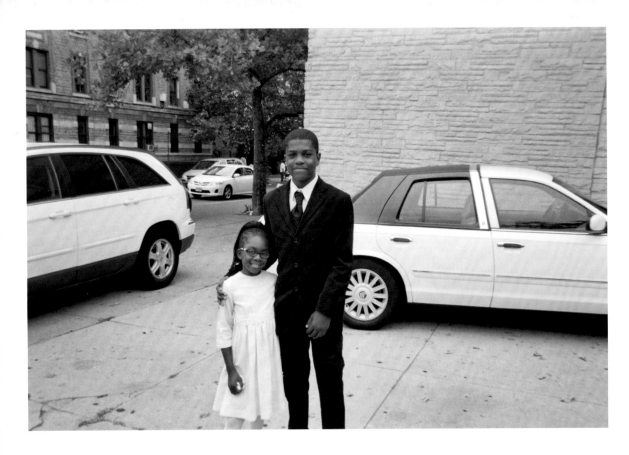

Our church, First Baptist of Crown Heights. When I was living in Brooklyn I was born into that church.
So, when I moved to the Bronx I continued to go to that same church. I started going to
that church in the 70s, and I've been going there ever since. I sing in two choirs and I'm on two usher boards.
We just stay busy, and we enjoy ourselves. This is my niece and nephew at church. They sang in the choir.

— **IRENE YOUNG BACCHUS**

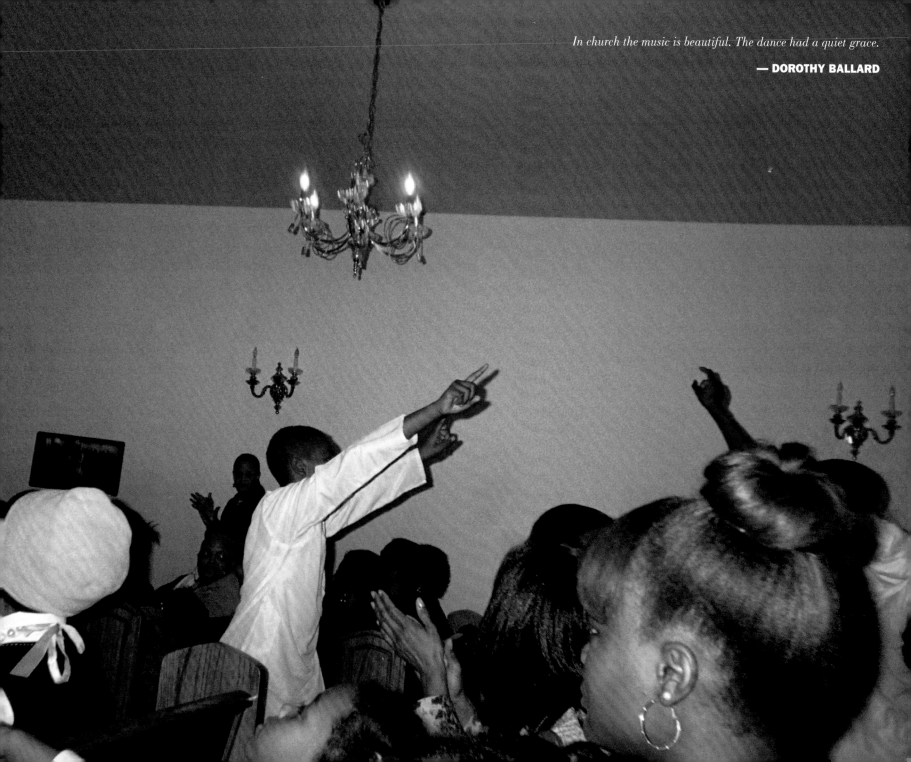

In church the music is beautiful. The dance had a quiet grace.

— DOROTHY BALLARD

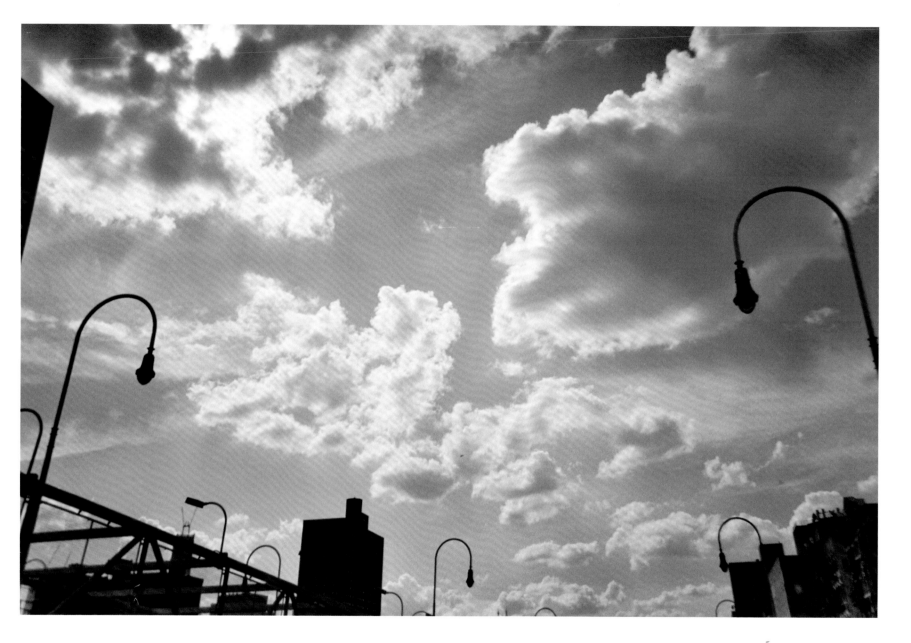

Cloud formations. Impending rain.

— SHEIK BACCHUS

AFFORDABLE HOUSING: THE CRISIS IN CONTEXT.

Thursday, 4 p.m., February 2013. The 33 towers are gone now from northwest St. Louis, the last inhabitants having fled to other locales (among them Ferguson). Scattered buildings remain—an electrical substation, several churches, a firehouse, a library, a vacant field office, and of all things a junior naval academy—serving as both sentinels and a warning.

In the Manhattanville housing project 900 miles east, a still spry 70-something matron proudly aims her camera at her grandchildren inside her cozy apartment, they're lit by the late-afternoon winter sun shining through the window, she seeing her features in theirs for perhaps the first time.

Like so many other tales, this one involves hope in the face of adversity.

Our backstory concerns homes (in the eastern city, though we will return to Missouri from time to time). Clothing, food, and shelter make up life's basic needs. Attire comes cheap and lasts for months or years, but an estimated one in six Americans cannot afford sufficient nourishment at times. Substandard shelter makes nutrition, not to mention a stable job, health, and education, an even harder lift. And more and more people—New Yorkers especially—are finding it beyond their means to rent a decent place to live, making it an urgent matter to preserve the affordable housing that does exist.

Excluding off-the-books tenants (said to be numerous enough in their own right to populate a medium-sized American city), some 400,000 low-to-moderate income New Yorkers dwell in 2,563 buildings in the city's 334 public housing projects. Once universally admired, these communities of red brick have fallen on hard times. Declining government support of an aging infrastructure has, in the 21st century, encouraged crime while discouraging all but the most essential repairs, at times leaving the incredulous, frustrated residents to fend for themselves. Worse, a media focus on the frayed edges has tarred even the most stalwart denizen as an unwelcome guest at the American party, dampening the prospect of funding once over.

Yet, given the opportunity to document their own lives in the projects, hundreds of residents participating in a novel photography program have focused, as you've seen and will see, not on bullet casings in the torn shrubbery, nor peeling toilets that long ago flushed their last, but rather on the joys of everyday life in an environment worth preserving, if not improving. The elderly grandmother, the working single-parent and children, and the handicapped veteran, they all persevere—and more.

WHAT IS NYCHA? In 1934, as the Depression tightened its grip, New York City took stock of the jobless and the slum-dwellers, and resolved to put people to work building decent homes for model tenants, not expressly as a way station to permanent private housing. Pioneered some years earlier in then-socialist Vienna (to this day a city continuing to set the pace for doing it right), the idea of public housing as a physically appealing municipal service had spread across Europe and crossed the pond. Soon, the concept made its way across the country. But the agency established to run Gotham's new enterprise, the New York City Housing Authority, aka NYCHA, remained the national gold standard, its sturdy apartment houses and welcoming playgrounds persisting in place long after abandonment elsewhere.

Almost a third of NYCHA's 12,000 employees reside in the projects, giving the agency the feel of a pre-New Deal company town, another locale where many paid rent to their employer. These 4,000 employee-residents provide NYCHA with a unique set of eyes on the street. (And along with managing the projects with such help, the agency administers federal Section 8 rent subsidies in private housing.)

The vast scale of New York public housing continues to surprise many. Spread unevenly across the city's five boroughs, the projects account for 8.2% of all apartment rentals. The red brick towers represent New York as much as any structure. The city's biggest landlord, NYCHA remains one of the nation's largest as well.

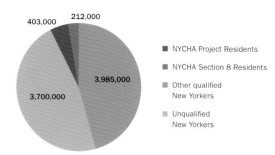

403,000 212,000

3,985,000

3,700,000

■ NYCHA Project Residents
■ NYCHA Section 8 Residents
■ Other qualified New Yorkers
■ Unqualified New Yorkers

NYCHA RESIDENTS AS SHARE OF 4.6M QUALIFIED & 8.3M TOTAL NYC POPULATION, 2014

NYC housing project residents total 403K, while 212K other NYCHA customers live in semi-privatized public housing known as tenant-based Section 8, also administered by the agency. This 615K total, rivaling the population of Boston, represents **7.4%** of the 8.3M total New York residents. Demonstrating the potential market for public housing in NYC, these 615K represent only **13.4%** of about 4.6M New Yorkers with low enough incomes to qualify according to federal standards, the latter comprising over half the NYC population.

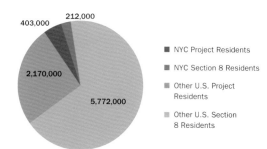

403,000 212,000

2,170,000

5,772,000

■ NYC Project Residents
■ NYC Section 8 Residents
■ Other U.S. Project Residents
■ Other U.S. Section 8 Residents

NYC PUBLIC HOUSING RESIDENTS AS SHARE OF 8.6M U.S. PROJECT + TENANT-BASED SECTION 8 TOTAL, 2014

The 403K in New York's projects represent fully 15.7% of the estimated 2.6M American project-dwellers, while the 615K NYCHA total accounts for 7.2% of about 8.6M in either form of public housing.

The height of the NYCHA building boom, 1965. Only one project dates from this century.

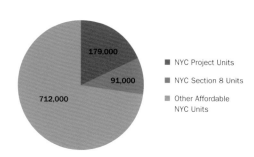

179,000

91,000

712,000

■ NYC Project Units
■ NYC Section 8 Units
■ Other Affordable NYC Units

NYC PUBLIC HOUSING UNITS AS SHARE OF 982K NYC AFFORDABLE RENTAL UNITS, 2014

The 270K NYC public housing units (179K project + 91K Section 8) account for **27.5%** of the estimated 982K affordable housing rental units in NYC, with rent within 30% of renter income. (Other forms of NYC affordable rental housing include Low-Income Housing Tax Credits, Mitchell-Lama, and Inclusionary Zoning, while rent stabilization and rent control regulations limit rent increases.) NYC public housing by itself accounts for 1.2% of around 21.9M American affordable rentals.

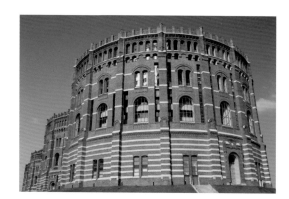

Foreign cities continue to build imaginative public housing, like this refurbished Viennese gas depot.

THE DEFUNDING.

NYCHA depended almost from the start on aid from federal, state, and city governments, funding construction while closing the gap between what residents could afford to pay (the user fee) and the cost of building upkeep. Attacked from the right during the 1940s and 50s as communist-inspired, then mocked from the left in the 1960s as architecturally isolating, New York public housing reflected the spirit of the times, abandoning its exacting tenant standards in 1968 and opening the gates to all comers. Federal legislation in the late 60s capped rent as a percentage of income and rendered American public housing more affordable, yet backfired by undermining building maintenance as housing agency rental income fell off a cliff. Helped by other federal programs, whites moved from projects to the suburbs, unwelcoming to minorities. The opposition of middle-class Forest Hills, in 1971, to a new project would effectively end public housing construction in the U.S. Crime began to rise in the New York projects and then exploded in the late 1970s.

Meanwhile, near the banks of the Mississippi occurred the most shocking event in the history of American public housing. After a decade of trying to hold the line against not only crime and disrepair, but also high vacancies arising from an emptying out of the entire city, the local housing authority brought down the Pruitt-Igoe housing project in 1972–76 with dynamite (an eerie foreshadowing of the 9/11 collapse of the Twin Towers, built by the same architect, whose design reportedly contributed to both failures—another link between the two cities). The image of government destroying its own creation upon realizing the futility of its effort resonated like the healthcare.gov debacle four decades on, but many times more powerfully, never redeemed by new customer enrollment. It marks the time when, already reeling from Great Society failures, Watergate, the Vietnam War, and endless stagflation, Americans began to lose faith in government as an effective agent. Not only project housing but the entire public sector began to be written off. The nation's leading right-wing economist caustically observed that if the federal government were placed in charge of the Sahara desert, in five years there'd be a shortage of sand. He was not alone in his views.

When a politically centrist American president toured the burnt ruins of the South Bronx in 1977, he pointed to a NYCHA project, remarking it seemed the only decent housing around, but conservative administrations and/or legislatures to follow would reduce federal operating support of all public housing thereafter. (One president would often jokingly liken the White House to public housing.) On one level, the cutbacks reflected disgust with periodic corruption scandals in the federal housing bureaucracy as well as the change in racial makeup of those housed, and how much public support had eroded in response to the crime wave. More profoundly, the pullback stemmed from what changed in American society during the pivotal decade of the 1970s: that loss of faith in government; ascendant right-wing ideology as social concerns trumped economic ones; the restoration, in broad economic terms, of capital's dominance over labor; de-industrialization and globalization's other attendant challenges to the American economy; the collapse of unions; the growing sense that Americans need not take care of other Americans. The defunding continued even as NYCHA began the long climb back by beginning, in 1995, to grant working families preference in obtaining apartments, and as crime in the projects began to abate following city and national trends. New York State walked away from its funding responsibility in 1998; NYCHA sued but could not stop it. The city left the building six years later, and, beholden to the mayor, the agency kept its own counsel. Federalization of state and city-funded projects in 2010 would entitle NYCHA to an unreliable and partial offset from Washington of these losses going forward but do nothing about the massive interim hemorrhaging. Staffing would be slashed from 16,000 in 2001 to 12,000 in 2014.

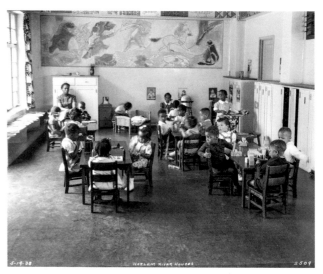
Nursery, Harlem River Houses, 1938

THE WAY IT WAS

Within a few decades, almost all whites would have departed, while New Yorkers of color might be forced by circumstance to remain in the projects generation upon generation.

1934	1944	1954	1964	1974	1984	1994	2004	2014
NYCHA founded; strict entrance requirement		Triple subsidy	Gates opened	Forest Hills revolt	Federal cutbacks begin			State, city subsidies end
						Working family preference		

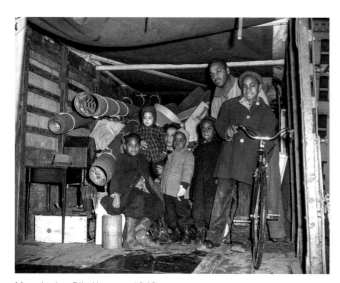
Move-in day, Riis Houses, 1948

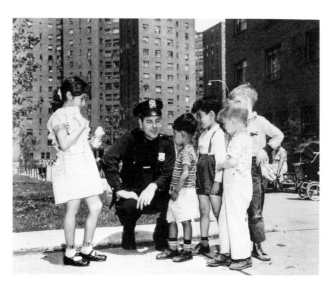
Meet and greet, Smith Houses, 1953

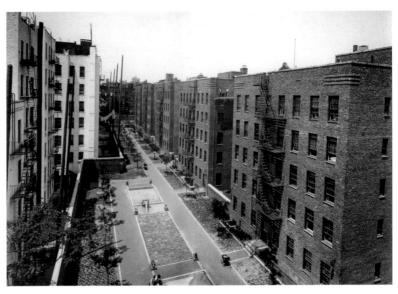

Construction of NYCHA's first project, 1935

According to widely available data, NYCHA has borne a catastrophic $1.2 billion cumulative shortfall in U.S. operating funding 2001–14 vs. what the federal government itself has deemed necessary. U.S. capital funding has declined by a crippling $1 billion in the same period. And so the cost to rehabilitate all buildings as needed would, by 2014, total an unfunded $18 billion—yet cheap compared with a replacement price tag of almost $70 billion. As noted by the city's foremost affordable housing advocacy group, the Community Service Society, the savings achieved by government disinvestment were effectively passed on as costs to vulnerable residents. Other public housing authorities have been somewhat proportionately shortchanged, while the demand for federal housing assistance in general so far exceeds the supply, that local affordable housing advocates have been reduced to exploring the use of Medicaid as a funding source, arguing that substandard housing constitutes a health issue in disguise.

Meanwhile, desperate to stop losing ground, NYCHA began to toy with privatization, notably with its abortive 2013 plan to lease project land for market rate housing.

TOP TEN REASONS WHY NEW YORK SUCCEEDED WHILE OTHER CITIES WITH PUBLIC HOUSING FAILED

1. Merit-based staffing

2. Community programs including job training

3. Triple subsidy from U.S., State, City 1938–1998

4. Tenant type preference 1934–68; 1995–present

5. Landscaped projects sited centrally near transit

6. Residents hired as staff

7. Liberal political climate

8. Openness to European ideas

9. Widespread apartment management expertise

10. No stigma associated with apartment living

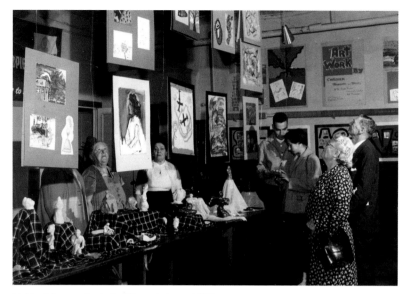

Not just four walls, but a life: art show, 1956

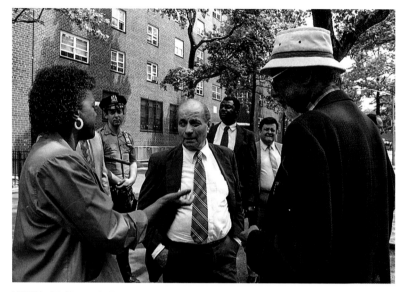

NYCHA chief buttonholed by tenants, 1989

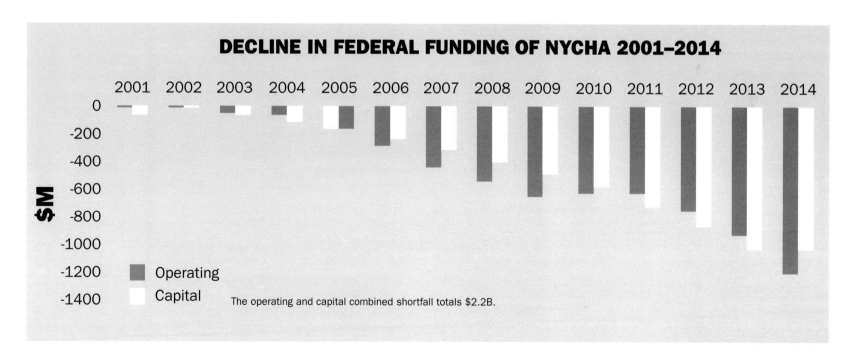

DECLINE IN FEDERAL FUNDING OF NYCHA 2001–2014

2001 2002 2003 2004 2005 2006 2007 2008 2009 2010 2011 2012 2013 2014

$M

0
-200
-400
-600
-800
-1000
-1200
-1400

■ Operating
□ Capital

The operating and capital combined shortfall totals $2.2B.

57

THE DEBATE.

The federal shortfall most recently appears driven by concerns about the deficit following the economic meltdown of 2008. Apparently throwing in the towel as this book went to press on trying to raise the level of federal support in such a climate, NYCHA supporters began urging instead a massive financial commitment by the state and city, along the lines of U.S. aid to Europe following World War II (though there is a much closer precedent at hand). However, such appeals would somehow need to deal effectively with the views of the city's own comptroller, who in 2014 questioned the ability of the agency to spend efficiently the funds it does receive, citing a tradition of incompetence and a lack of accountability (though he himself would develop funding ideas).

Substantial back-and-forth on the productivity of NYCHA can be anticipated—both as one among many public housing authorities and even vs. private property management firms. Compared with its sister agencies across the country, NYCHA remains something of an outlier in its command and control of project management—making limited use of outside firms while directing all activities from the central and borough offices—and the impact of this behind-the-times model can be felt in NYCHA performance. Plans seemed afoot in 2014, though, to devolve more powers to managers on the ground in the projects themselves. Could the agency be compared with private management firms directly? Not easily. Tenuous, if not fatuous, comparisons with the performance of the private sector have bedeviled government at all levels for a generation. The two play on an uneven field shaped by the public itself.

For one thing, the public sector must serve all customers, profitable or not, while bound by time-consuming and costly procurement regulations that do not constrain private firms. Meanwhile, taxpayers naturally won't permit encouraging exceptional staff work in the public sector with the atmospheric salaries and bonuses that corporations use, while public concerns about corruption lead to an emphasis on work rules rather than value creation; top talent seeking high financial compensation and/or opportunities to work outside the box tend not to place government jobs at the top of their lists. In this context perhaps it's striking the public sector works as well as it sometimes does, if rarely in housing the needy.

Still, the few outside firms helping NYCHA manage its projects do seem more productive—and somehow without raising the bar for NYCHA's own management. Could there be opportunities for NYCHA to move the needle without simply outsourcing more work? It is not unheard of for a public sector union to match the productivity of the private sector and thereby retain the work in-house, one way to bring competitive pressures to bear on the public sector that stimulate productivity in the private realm. Also, NYCHA management's contentious relationship with the unions strongly representing much of the workforce, particularly the caretakers, groundskeepers, maintainers, etc. who account for 9,000 of the agency's 12,000 staff, typically focuses on pay and work rules. The question arises if more could be achieved were the two sides to cooperate on boosting the health of the entire enterprise as in Germany's widely admired "co-determination" practice. But the housing authority's biggest handicap may be that, typically for a government agency (and unlike the USPS facing off

THE FUNDERS:

Washington D.C.

Albany

City Hall

against FedEx and UPS, or Amtrak battling the airlines for market share), NYCHA as a whole directly competes against no noteworthy affordable housing provider, only vying with public housing agencies elsewhere for federal dollars. It does not even need to market its services. The project waiting list comprises 250,000 families.

Further debate can also be anticipated on the relative merits of federal vs. local funding of such services as public housing. What may help NYCHA's case: New Yorkers provide far more tax revenue to the federal government than it receives back in return. And according to some, the federal government provides more housing assistance to the wealthy through the tax system (e.g., the mortgage interest deduction) than it does to the poor through public housing. Still, the federal role can be diminished further, with one national party suggesting in 2014 that support of all such local programs be packaged into block grants to the states, they to direct funding in line with their own preferences. Be that as it may, the federal government is not going away anytime soon; its role will likely loom large for affordable housing and American society as a whole for the foreseeable future. Meanwhile, throughout the West, the welfare state remains the last model standing, with the public sector's reputation continuing to suffer even as its responsibilities continue to expand. Government's successes are taken for granted while its failures remain more dramatic and disturbing than almost any mishap lain at the door of the private sector.

All in all, NYCHA will need to argue its case extremely well to earn more support from any quarter. The photographs in this book may clinch it.

THE AGING.

The defunding of NYCHA would have been enough to send the projects into a downward spiral. On top of this, by 2014, two thirds of the 334 projects (including nine in ten of the dwelling units) had more than 40 years under their belt. "With older buildings come complex needs," explained PlanNYCHA, the agency's 2012 effort to reinvent itself. "Older buildings require capital improvements to repair roofs, elevators, and brickwork. Major upgrades are needed regularly to ensure that heating, plumbing, and other systems continue to function properly." So the projects required additional financial help even while the federal government decimated ordinary funding, all but ensuring that NYCHA could not keep up. Other cost rises, including that of utilities servicing the projects, compounded the problem, as arguably did the

agency's disinclination to enforce the eight-hour-a-month federal community service requirement mandated of all public housing residents.

In 2014, most buildings failed to comply with local code governing exteriors and facades, with the city allowing only NYCHA free rein here among all NYC landlords. Leaky roofs led to collapsed ceilings, leading in turn to dangerous infestations of mold. Mice and cockroaches enjoyed free entrance through unpatched holes. Broken windows abounded. In especially dire straits in 2014 were the 13 projects whose 70 years of age exceeded their useful life. Finally, almost 800 apartments stood uninhabitable by NYCHA standards in 2014 and by necessity remained vacant.

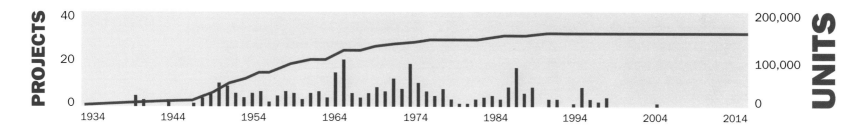

The columns show NYCHA's 334 projects by the original construction year or the date of renovation. The prime year of original tower construction was 1965, when 22 were built; by contrast, the 17 projects dating from 1986 involved rehabs or low-rises, funded only by the state and city. By 2014, most projects had over 40 years under their belt, while 13 had logged more than 70 years, past their intended life. The line represents the cumulative number of new or rehabbed dwelling units by year. It shows that projects older than 40 years account for nine in ten apartments.

In 2014, most buildings failed to comply with local code.

THE IMPACT.

When funding dries up as the buildings age, crime and disrepair result, the bane of resident life. The two impacts reinforce each other in a vicious cycle, as when broken lobby doors invite in thugs who may then proceed to unhinge them altogether, allowing in one and all.

NYCHA violent crime lagged behind the city rate until 1985, then passed it and never looked back. Crime in the projects has reportedly also surpassed crime in the surrounding neighborhoods. As one expert on NYCHA put it, "Rikers Island and Sing Sing became de facto annexes of NYCHA developments." Drug gangs of the 1990s, motivated by monetary gain, metamorphosed by the second decade of the new century into something less rational and so much more frightening yet: warring tribes of troubled teens defending imaginary turf, youthful residents who find jail more comforting than home. As a NYC crime expert concluded in 2014, "Public housing projects exist socially, economically, and physically at the extremes of all the conditions that we know are correlated with crime." Having been forced to yield control of its own community police force to the city in the mid 90s, NYCHA could only stand by as some NYPD officers reportedly drew guns unprovoked and others did not dare patrol ill-lit stairwells even while the mounting violent crime rate neared only one-third of the 1989 pace, with monitoring by yet other NYPD officers of closed circuit television cameras (CCTVs) mounted in the projects possibly ineffectual at times. (Yet until the policy ended by court order and the new city administration in 2014, the police stopped and frisked young black men on the project grounds, like everywhere else in the city, merely on suspicion of carrying guns—arresting those found with even small amounts of marijuana, in line with racially imbalanced law enforcement practices across the country.)

All the while the good tenants, the vast majority, have cried out for police protection from the bad, not to mention from external threats.

Though skittish at times about NYPD tactics, NYCHA field staff reportedly cried out as well, crime victims themselves and frequent targets of jars of mayonnaise and such prankishly tossed out of upper-story windows by the tiny out-of-control minority, while conceivably suffering collateral damage from various armaments heedlessly dropped down the garbage chutes by some of the same wrongdoers into the trash compactor rooms below. Door-to-door visits to collect back rent from some might frighten a Hollywood superhero. (State legislation in 2014 finally defining attacks on staff as a felony instead of a misdemeanor, similar to the protection offered any city bus driver and which had been fruitlessly advocated for years internally could only help the situation.)

5% OF NEW YORKERS LIVE IN THE PROJECTS (2014)

20% OF VIOLENT NYC CRIME OCCURS IN THE PROJECTS (2014)

Meanwhile, funding cutbacks forced project residents to wait years for minor repairs by the fall of 2010, when the maintenance backlog reached 106,000. By January of 2013, the backlog had quadrupled. Preventable failures including vandalism, graffiti, and pipes choked with cooking grease contributed to the volume. Only an emergency infusion of $10 million by the city, along with an equal sum wrung from elsewhere in NYCHA's annual budget and redeployed to the front lines, allowed the field staff to bring the number down. Still, by the summer of 2014, the Community Service Society would label NYCHA arguably the city's worst landlord, the impact of defunding and aging compounded by less than transparent agency practices about both its financial situation and its response to requested repairs.

422,639 backlogged repairs (2013)

One wonders what those who live in the New York projects were to do in the 21st century. What recourse have they had, but to remain in place, often (by the agency's own 2011 admission) huddled inside their apartments for safety, launching the occasional lawsuit for relief, hoping against hope for conditions to improve? Public housing had been built as a refuge for families suffering through a bad patch, but as New York City became an increasingly expensive place to live in the new century, fewer and fewer housing alternatives survived, with these residents facing the highest unemployment rate in the city. As the apparent sage in the indie film *Red Hook Summer* crystallized the resident plight in 2012, "Folks were supposed to use this place as a stepping stone. And then there was no place to step to because they gave it all away."

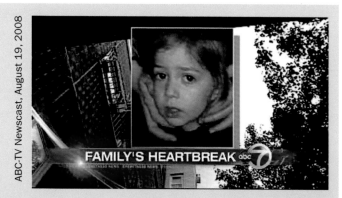

ABC-TV Newscast, August 19, 2008

DISREPAIR STORY

Jacob Neuman headed out the door of his home on the 11th floor of the Taylor-Wythe project in South Williamsburg at 9 a.m. August 19, 2008, bound for the local Talmudic academy. The five-year-old scholar with big brown eyes boarded an elevator that had been slated for modernization four years earlier but could not be renovated when federal funds failed to materialize. Now the conveyance became stuck between the 10th and 11th floors. Jacob tried to escape by jumping to the lower floor but lost his footing. And fell to the bottom of the shaft.

To make matters worse, the increasingly challenging conditions would become the only take of the city tabloids, television, and Hollywood on the New York projects. In a tragic twist of fate, the degradation of the environment portrayed by the mass media, to the exclusion of anything else, has generally led not to a determination to improve conditions, but a willingness to reduce financial support even further. Everyone in the projects, perpetrator and victim alike, in the end would wind up tarred with the same brush, suggesting the futility of further assistance. After all, to a greater or lesser degree, Americans associate public housing with crime, disrepair, lowered property values, a lack of physical appeal, and an inappropriate government handout—even while most support the idea of government guaranteeing everyone a place to sleep (and enough to eat).

CRIME STORIES

Seven-year-old Mikayla Capers boarded the elevator in East New York's Boulevard Houses in the early evening of June 1, 2014 with her best friend, Prince Joshua (PJ) Avitto, six—the lively girl and boy headed back home after playing in the hot sun. They may not have noticed the deranged heavyset six-foot grown-up, just paroled after serving time for assault, who had come unhindered past the lobby and gotten on behind them. The eight-inch kitchen knife came down on the pair again and again. Only Mikayla survived.

The elaborate security system that NYCHA had wanted to install throughout the projects based on Newark public housing's success (featuring not just CCTV but layered controls including mechanical lobby door locks, electronic access, and telephone intercoms) had not materialized, but the city council had provided the money for CCTV at Boulevard. Seemingly ineffective in dampening the overall crime rate and useless in curbing domestic violence, cameras by themselves may not have seemed top priority to the agency, which did not follow through. With many now unconvincingly but understandably asserting CCTV might have made the intruder think twice, the new mayor, blaming bureaucracy for the delays, committed his housing agency to an accelerated camera installation schedule at Boulevard and other projects. (In another hopeful sign, he had already relieved the agency of the $70 million annual burden of paying for its own city police protection, while bringing in a new NYPD leadership possibly more committed to working with the communities served; he would soon fund a $210.5 million multi-pronged initiative aimed at curbing crime in the most dangerous

projects.) Yet two months after the killing, when PJ's bereft mother filed the inevitable lawsuit, to the tune of a staggering $281 million and which blamed NYCHA for the unrepaired door locks as well as the missing CCTV, his father would point out that only a single camera had been installed in the meantime while the broken door continued to provide free access to one and all.

Meanwhile, the local tabloids had a field day. For its part, *The Wall Street Journal* weighed in with a pointed report on how routinely private property management firms treat camera installation in their own apartment buildings. Now the public vs. private sector comparison discussed earlier touched on the issue of public safety. Yet we have argued in this book that faulting the public sector per se is too simplistic. Those of a mind to demonize government might consider once-dominant General Motors, which, on the day before PJ's funeral, seemed to take a page from the mayor's book and blamed its own bureaucracy for thwarting the recall of the company's lethal passenger vehicles for more than a decade. Such observers might also consider it was not the government but the celebrated financial sector that nearly sunk the global economy in 2008, placing millions of Americans in the most challenging circumstances of their lives, leading to premature deaths for some and driving many onto the public housing waiting rolls—while (following a brief stimulus) giving Congress new reasons to shortchange civilian government agencies across-the-board, including NYCHA.

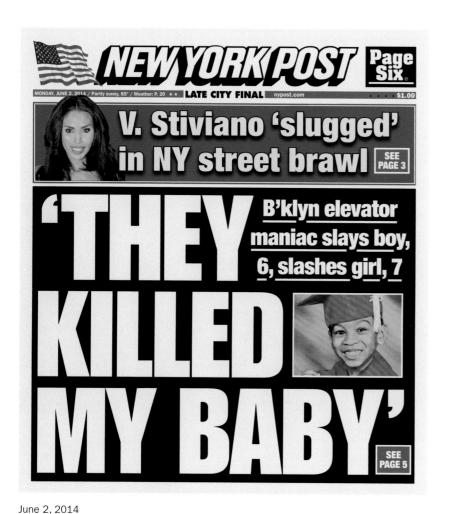

June 2, 2014

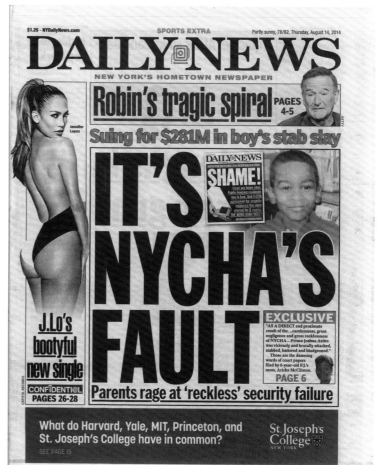

August 14, 2014

NEW YORK VIEWS NYCHA.

As the federal government was cutting back in 2004, New York City walked away from its ongoing financial support of its public housing, though forced to come to the table from time to time thereafter to staunch the bleeding.

Not coincidentally—and reminiscent of conditions at New York's transit agency experienced as employees by George and Jonathan following the city's fiscal crisis of the 1970s (manifested in the spread of graffiti from the outside of subway cars to cover the interiors as well, including windows and maps, with subway cars breaking down after an equivalent of fewer than three cross-country trips)—a loss of control began to set in throughout the housing authority, NYCHA losing touch with even who was living where. Rumors circulated about out-of-towners—from notorious fugitives seeking a hideout to A-list celebs fleeing the local detox center—decamping to NYC, each living large in a three-bedroom NYCHA apartment with a view of Central Park, unbeknownst to anyone at the agency. One confirmed tenant had been keeping both a tiger and an alligator in his seven-room apartment, only discovered when he stopped paying rent. Meanwhile, many New Yorkers, not all angry shut-ins (as the phrase du jour would have it), complained to the media about project residents staying put generation after generation, gaming the system by hiding income, occupying real estate in choice neighborhoods, and hanging out idly or worse. The agency itself was viewed by others as beyond dysfunctional, with a congenital disposition to paint an apartment just before sending in the plasterers, an inability to track supplies, and a blissful indifference to return on investment. Yet these views would be countered by many others, not even project residents, who pointed to the huge tax breaks enjoyed by developers and the unparalleled expertise of financiers in gaming a far larger system, challenging NYCHA's critics to keep New York a haven for all classes rather than a sanitized playground for the well-off. (As for the transit authority, its turnaround began with the MTA's $7.2 billion 1981 Capital Program, the first step in a 30-year, $84.3 billion rescue and maintenance effort launched by the state to ensure the public transportation network would serve New Yorkers for generations to come. The attempt succeeded. Graffiti makes only rare appearances and subway cars last the equivalent of almost three-quarters the distance to the moon without failing, while ridership is up 66% and violent crime down a remarkable 82%).

NYCHA's reputation in New York reached a new low by the summer of 2012, when the city's major tabloid acted the people's watchdog, launching a relentless, unprecedented campaign against the agency. Beyond crime and disrepair now came accusations that the housing authority failed to spend even what funds it did receive, amid characterizations of the former financial executive heading NYCHA as out of touch. The campaign, so fierce it made cynics wonder if the real-estate tycoon publishing the tabloid covetously eyed NYCHA assets, found an apparent ally in *The New York Times* that fall when the housing authority could not vanquish a new foe, Mother Nature. Superstorm Sandy wrecked havoc in projects from Red Hook to the Rockaways.

Recurring news reports of waste, fraud, abuse, and mismanagement among public housing authorities near and far—reaching a new low in 2011 when Philadelphia's agency confessed to using federal funds to obstruct a federal audit—provided the seedbed nourishing such hostility, dampening support for their mission nationwide and locally.

NYCHA would become so fearful of more bad press that any initiative became a hard lift; the dog in the Skinner box had been shocked once too often for no apparent reason and retreated sullenly into his corner. Predictably, further criticism followed.

Yet portrayals of the depths to which New York's once proud achievement had sunk finally stirred a corrective response rather than further abandonment. By the mayoral campaign of 2013, the one promise almost all candidates signed up to was fixing NYCHA, starting from the top. The new mayor's new agency chair would soon characterize the entire operation as beyond triage. Yet as we've seen, even with a new city administration and new agency leadership, crime in the projects—horrific crime at that—would not soon go away. Nor would the viewing of the projects only through prisms such as this.

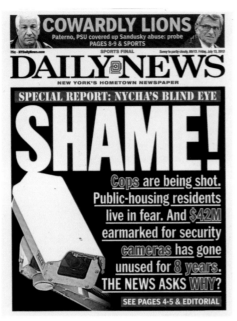

July 13, 2012

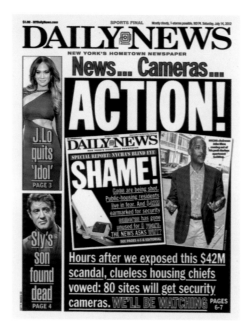

July 14, 2012

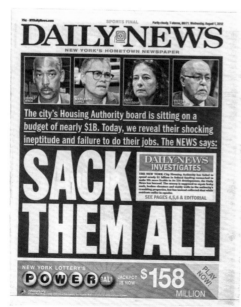

August 1, 2012

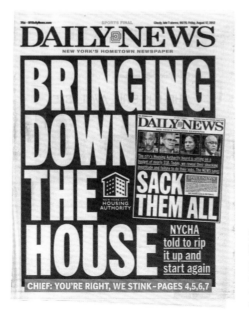

August 17, 2012

HOLLYWOOD AND BEYOND.

It was one thing for local tabloids and newscasts to focus on crime and disrepair. Movies magnified the imagery, transmitting it globally.

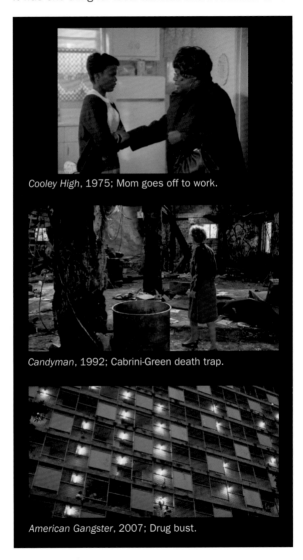

Cooley High, 1975; Mom goes off to work.

Candyman, 1992; Cabrini-Green death trap.

American Gangster, 2007; Drug bust.

One of the few films with public housing (in Chicago, as it happens) a benign setting.

Seventeen years on, the fitting locale of a horror movie.

NYCHA's Marlboro Houses stand in for Newark's Stephen Crane housing project.

Families of federal legislators representing American's heartland caught some of these movies at the local multiplex. How much would the Congressmen and women be inclined to fund public housing subsequently?

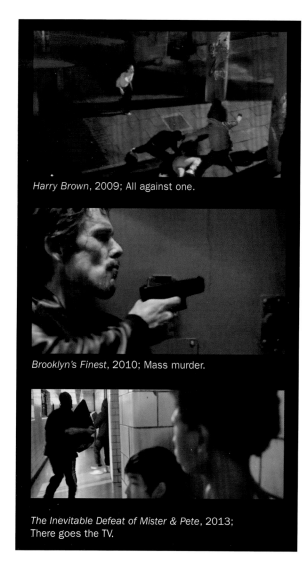

Harry Brown, 2009; All against one.

Brooklyn's Finest, 2010; Mass murder.

The Inevitable Defeat of Mister & Pete, 2013;
There goes the TV.

Not only America: Mayhem inflicted in estate
housing outside London.

No good guys live here in NYCHA's
Van Dyke Houses.

The truest project heroes since *Cooley High*, but
evil lurks in NYCHA's Ingersoll Houses.

Other notable films with a negative public housing setting include *Down the Project…From the Project* (1982), *Public Housing* (1997), *Legacy* (1999), *Brooklyn Bound* (2004), *Precious* (2009), *Son of No One* (2011), *Player Hating* (2012), *The Pruitt-Igoe Myth* (2012), *Red Hook Summer* (2012), and *Broken City* (2013). Meanwhile, nationally syndicated TV series including the entire *Law and Order* franchise portrayed the projects similarly.

Me and my friends were arguing over whether a warty amphibian with poison lumps sprays or turns clockwise and spits poison.
So yes it was really silly. So we went online to see who was right and I was right—they spray poison from their lumps.

— AALIYAH COLON

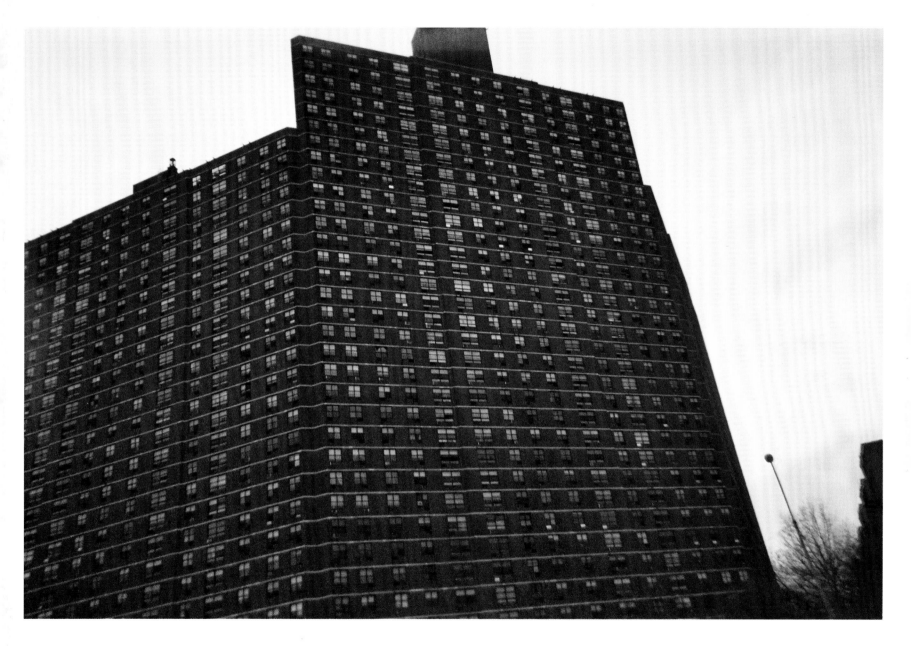

Can you count the windows? (Caption by Deborah Candreva)

— MARGARET WELLS

My home.

— CATALINA (TATA) TRINIDAD

Mi hija Rosi con su esposo Adolfo, tienen 28 anos de casados, estan en mi cocina.
(My daughter Rosi with her husband Adolfo. They have been married for 28 years. They are in my kitchen.)

— ALINA NAVARRO

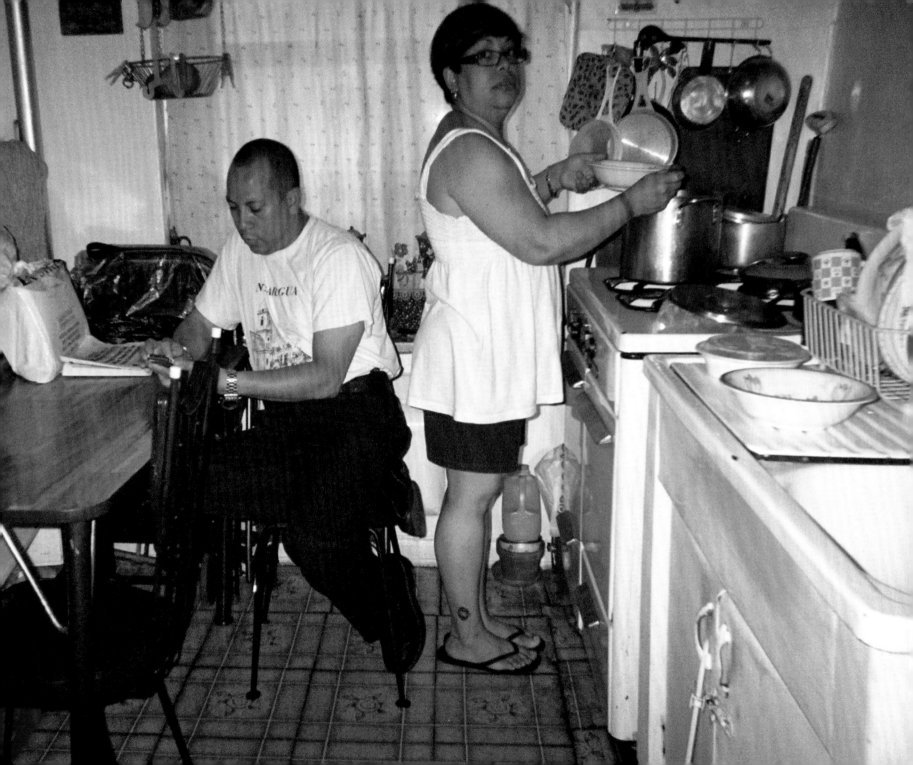

LASHANIQUE (ZNYA) MORNING

LINDA ERWIN

RAFAELA NOVA

Baby shower.

— DOROTHY BALLARD

Looking west on 135th Street and seeing New Jersey's towering buildings.

— MARGARET WELLS

My garden, I'll handle it with care.

— DOROTHY BALLARD

I collect dolls from all nationalities, different countries. I order them and get them when I'm traveling.
I have Michele Obama too, I have her doll from inauguration. I collect a lot of things—dolls, plates, elephants.

— HELEN MARSHALL

GEORGINA (GINA) BERMUDEZ

WENDY LIN

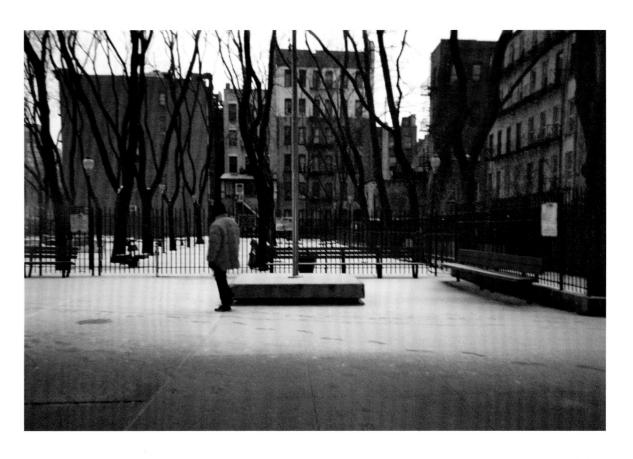

SUSANA ORTIZ

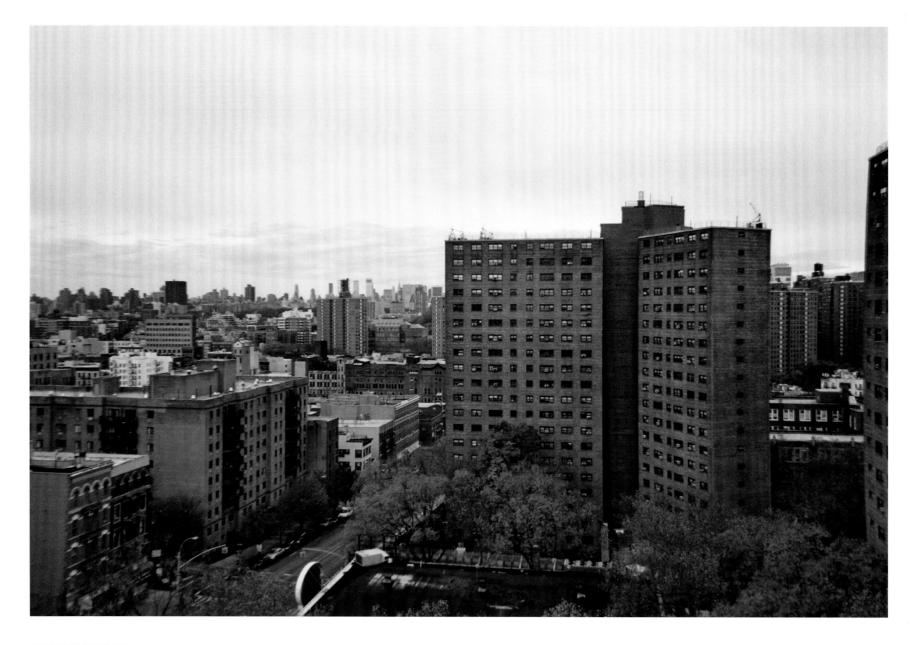

HELEN MARSHALL

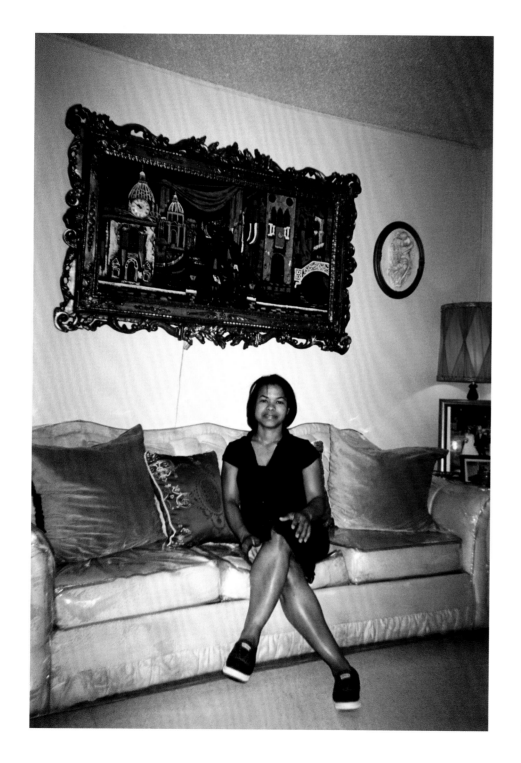

DELVERIN JENKINS

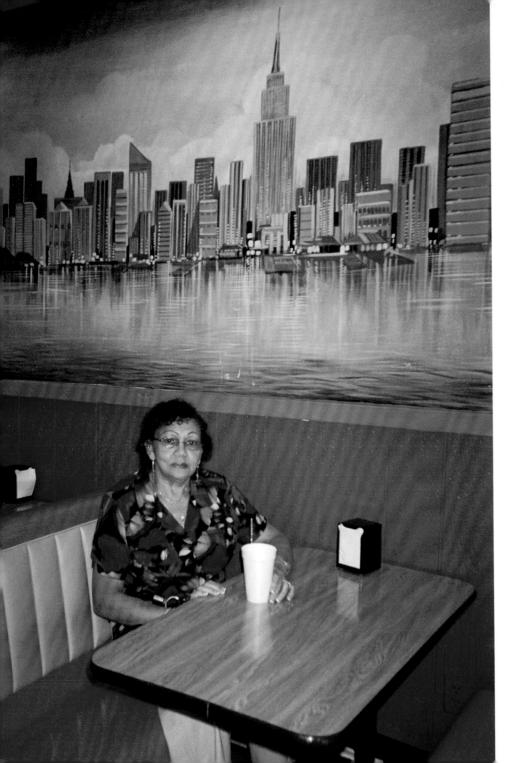

NURIS PADILLA

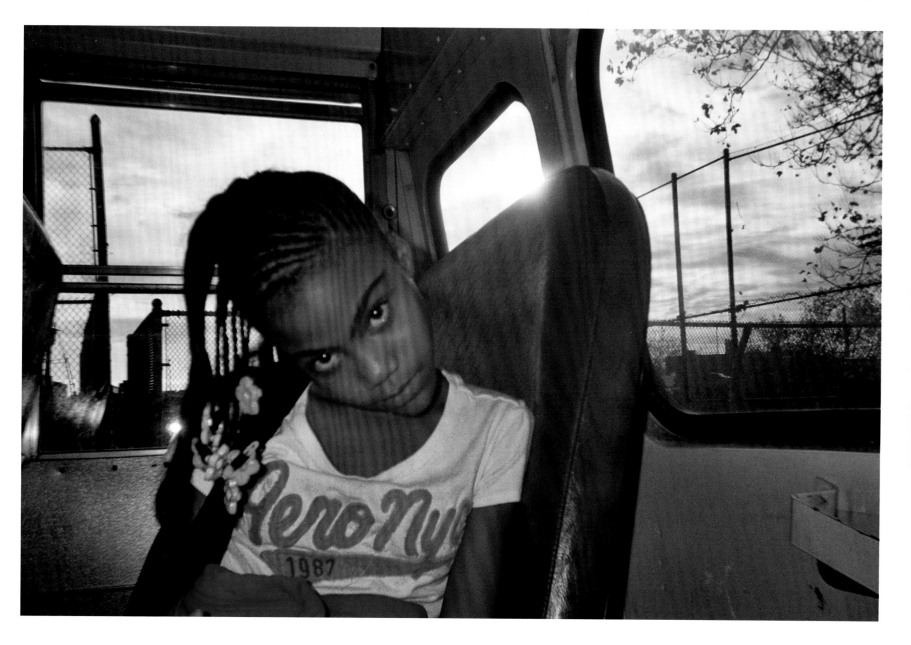

My friend on the school bus on the way to school.

— JAYLIE EFFERSON

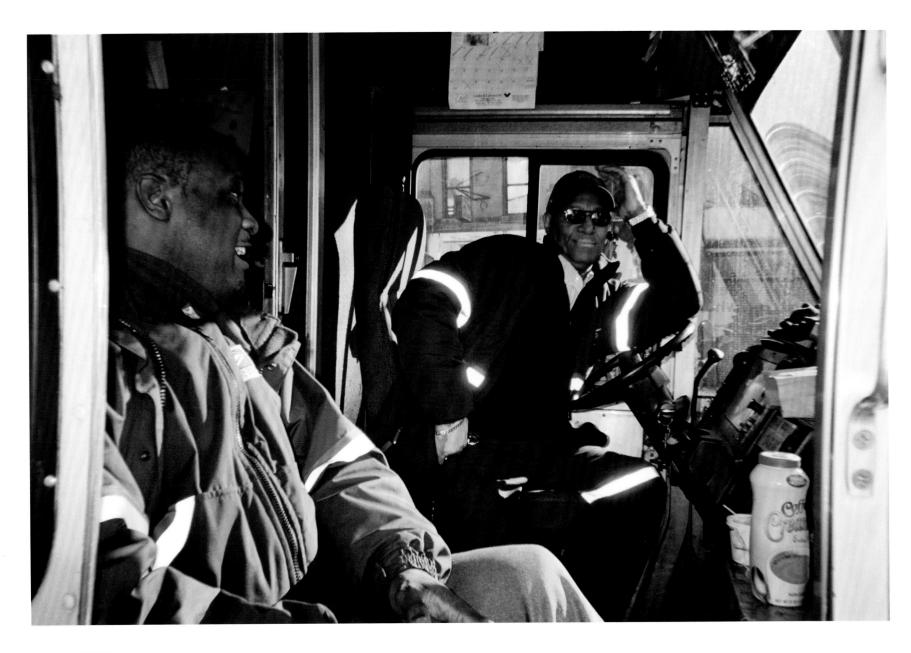

ROBERT HICKS

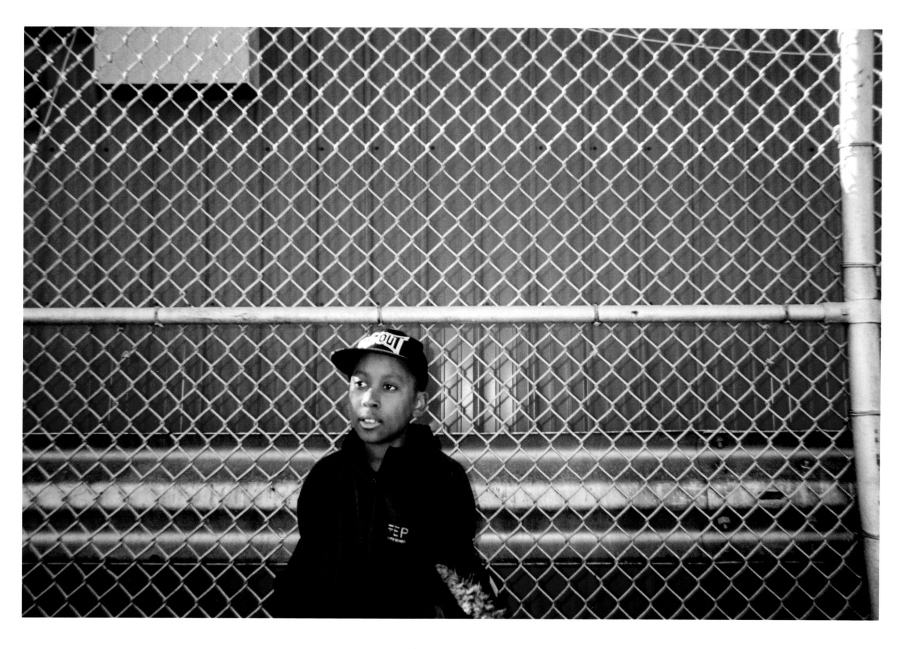

ELODIE JEAN-BAPTISTE

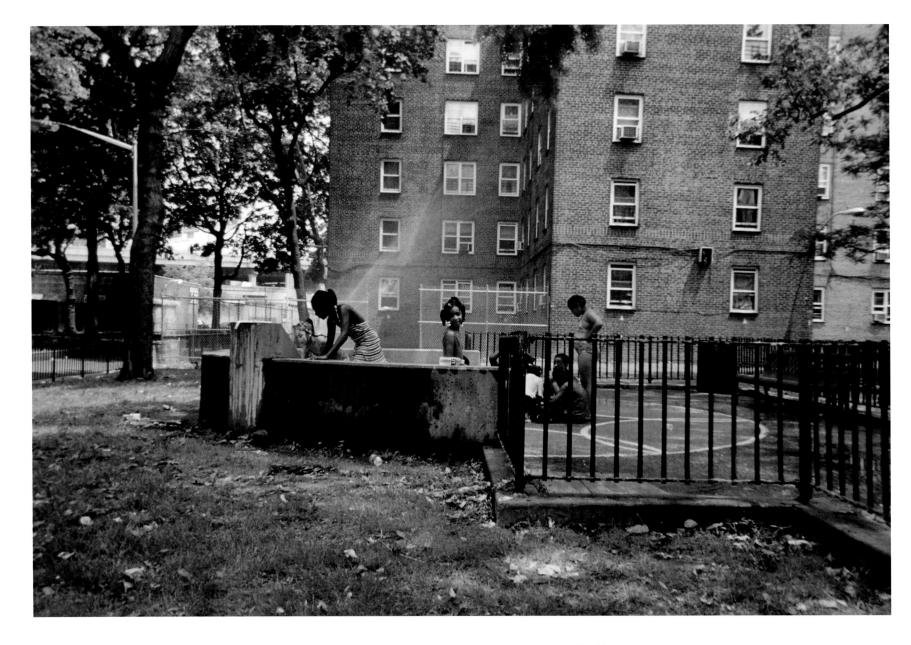

My cousins in the projects. There are three parks near my building.

— JARED WELLINGTON

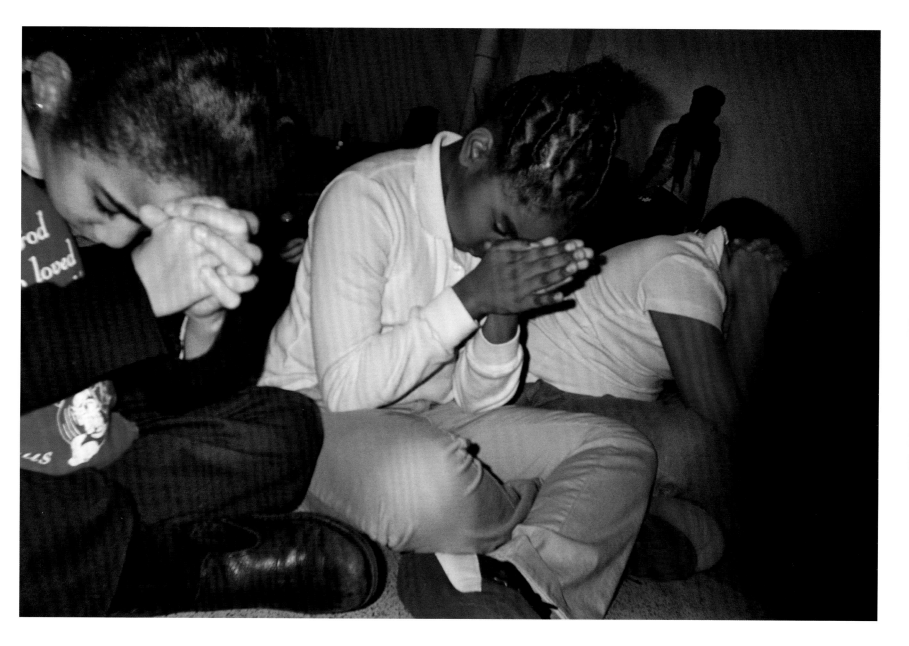

Every time Yogi Bear *ends we pray. Sometimes I go to the after school. We do our homework before going downstairs to play.*
We play games and win prizes.

— UVICA FRANCOIS

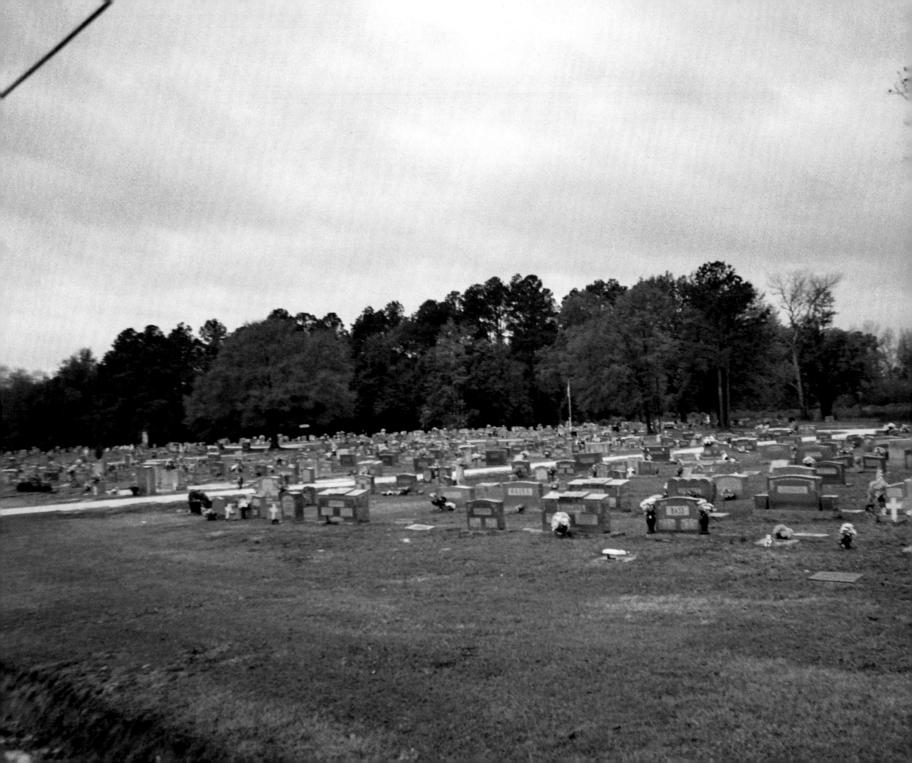

St. Raymond's Cemetery. Funeral in progress. Saying goodbye to a loved one.

— SHEIK BACCHUS

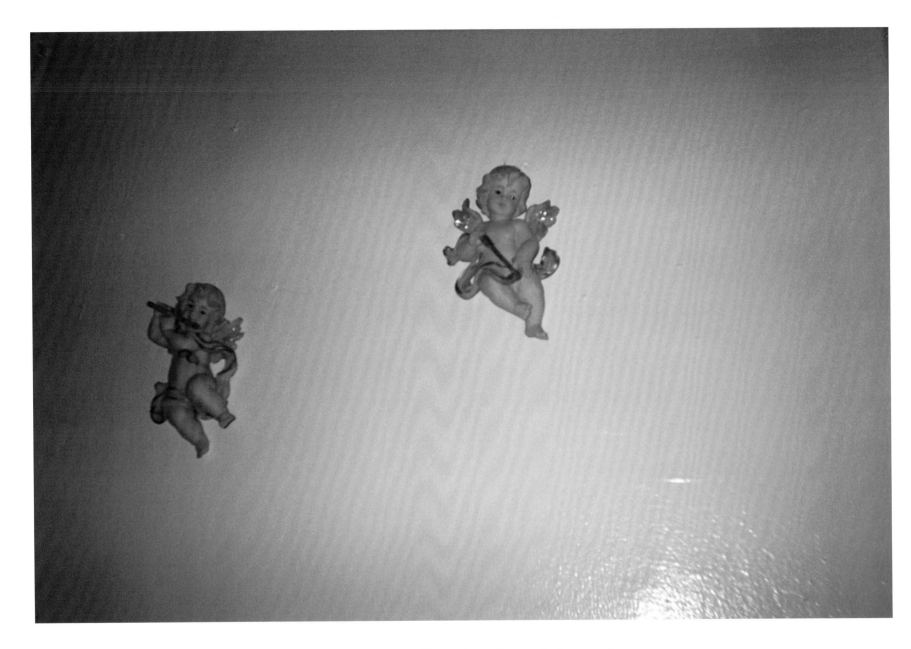

Angels on my grandma's wall reminds me of my cousin that passed away.

— KAYLA TORRES

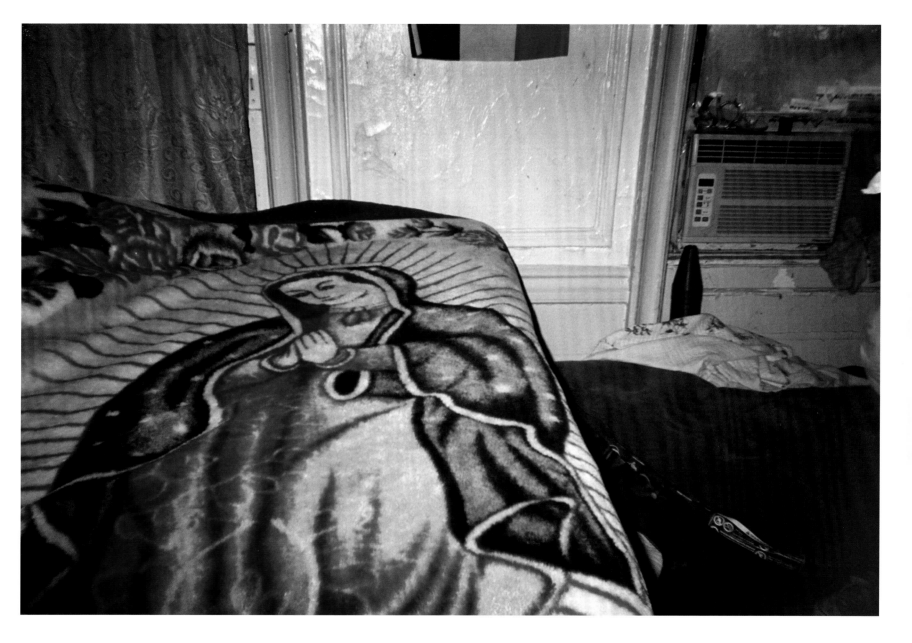

JIMMY ARAGON

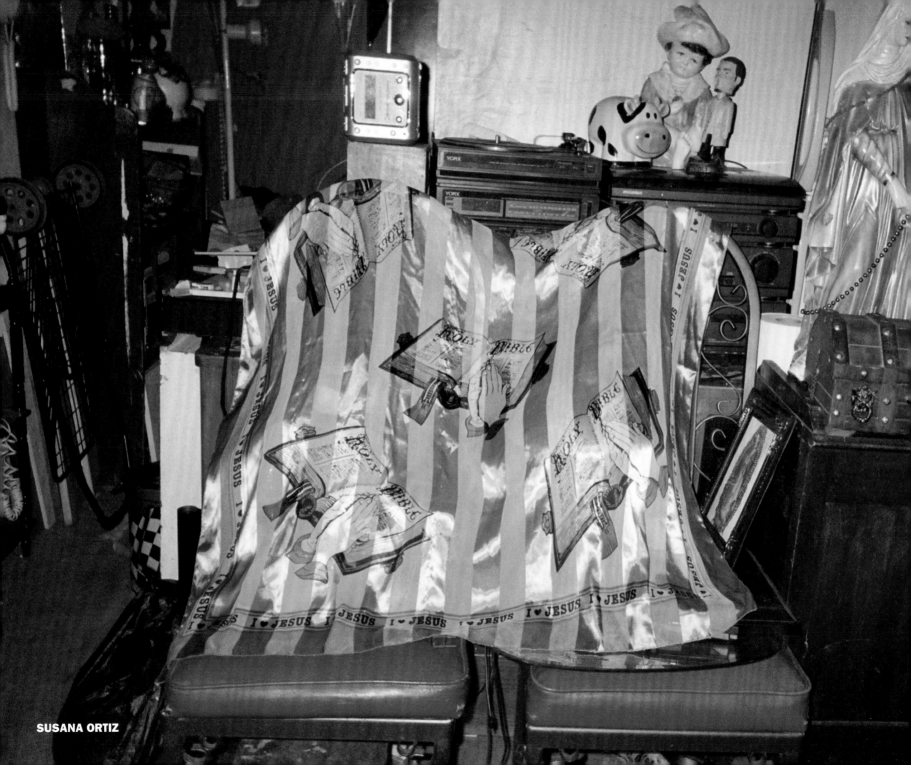

SUSANA ORTIZ

ELSA ALIMENTATO

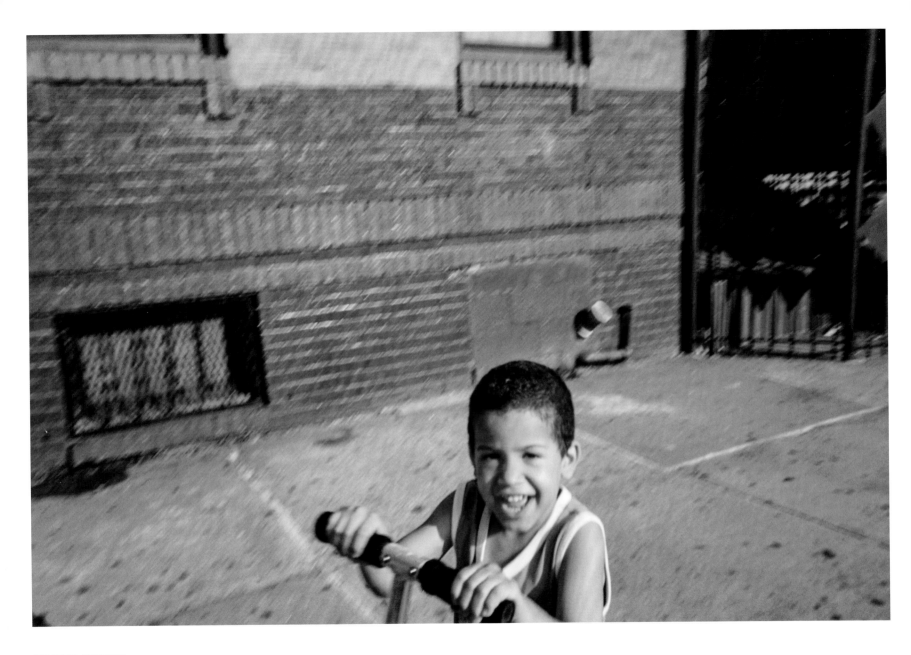

MOISES JIMINEZ

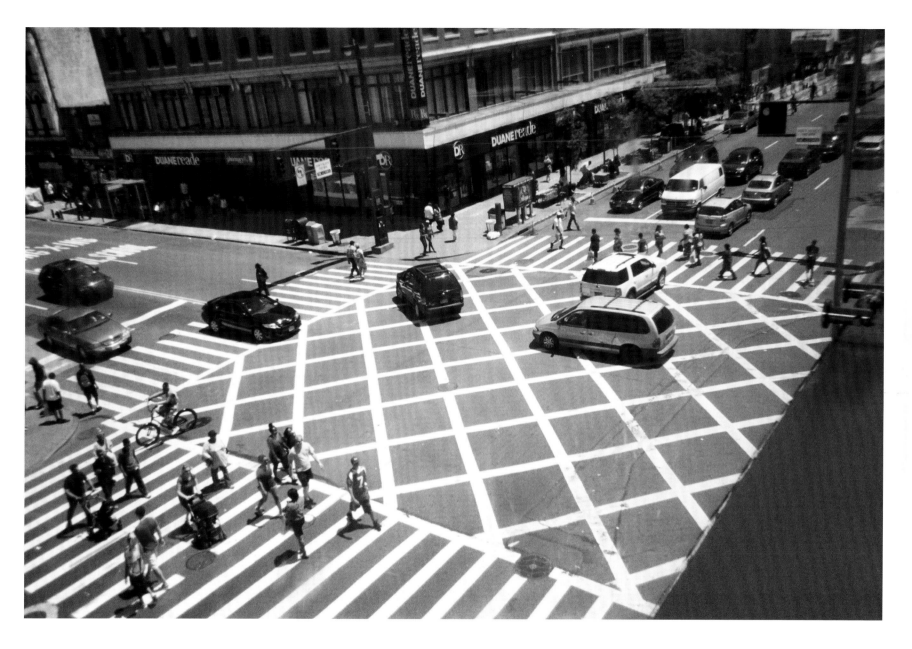

DOROTHY BALLARD

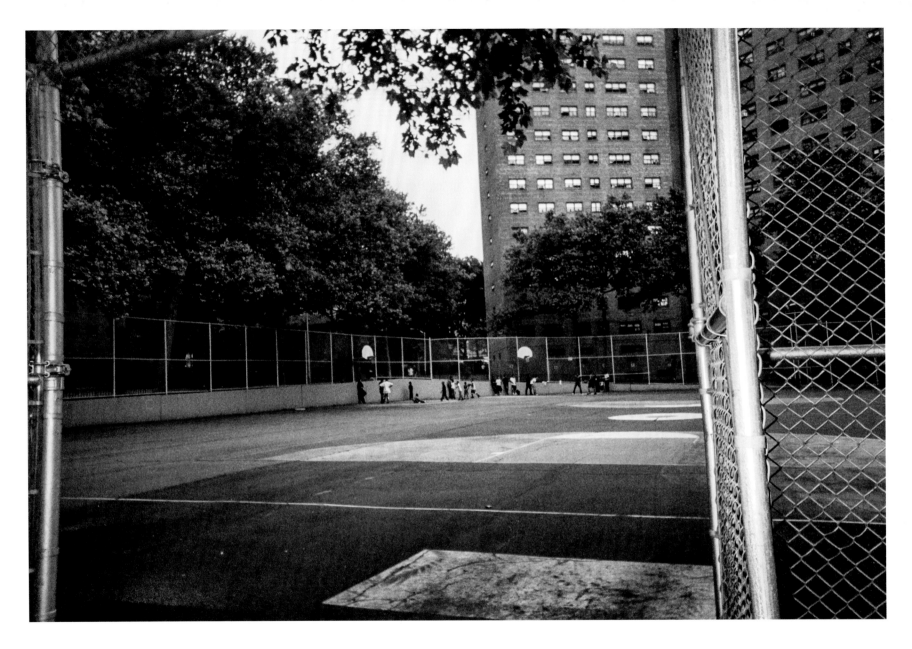

Remember when the ball field was a dust bowl? Now paved, kids love to play basketball.

— MARGARET WELLS

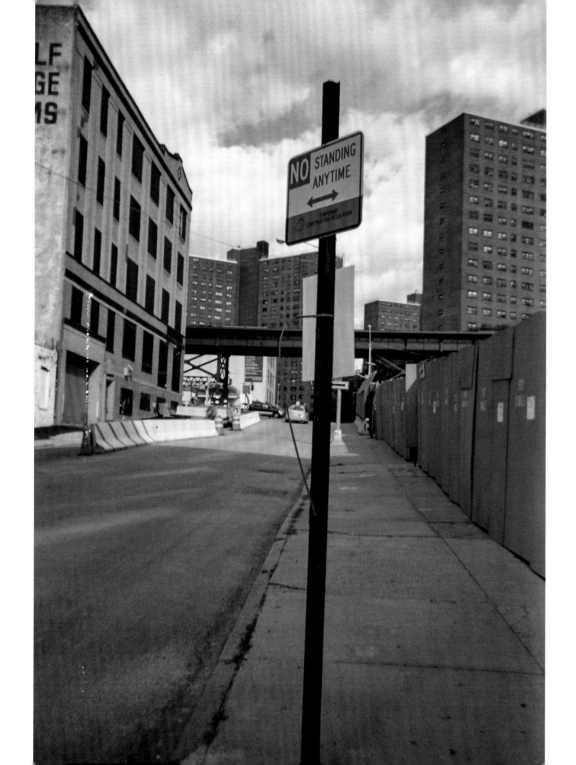

On a windblown city corner there
we stand, looking at each other, tears
streaming from our eyes, crying
over things that cannot be changed.
God says that tears are prayers.
So our prayers are lifted up to the
most high and he sends his words that
will not return to him void. All the
things we cannot change are answered
by him. And to us solace comes.

— **MARGARET WELLS**

THE STAKES.

Much rides on the success or failure of any effort, including Project Lives, to preserve New York's public housing—for the participants and other project residents, for the city, and for America. The federal government in 2012 advised NYCHA it was too big to fail. But that's also what the Treasury Department reportedly told Lehman Brothers, employer of the executive who would soon become NYCHA's chief, just before the Department pulled the plug on the investment firm, triggering the near global collapse in the fall of 2008. The huge structural deficit plaguing the agency since the funding tap began to dry up could, if not somewhat alleviated by showing the government a world worth preserving, one day leave NYCHA unable to pay its bills.

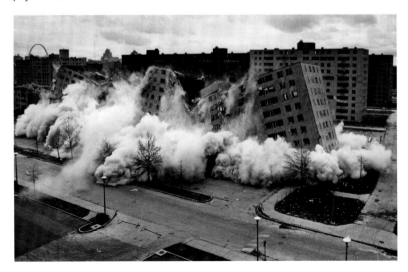

The iconic photo seen round the world and the specter haunting American public housing ever since: Pruitt-Igoe comes down, 1972.

If NYC public housing simply staggers on with limited funding, there may be more tragedies as befell little Jacob and PJ. If NYCHA actually fails, the participants in Project Lives, along with their 400,000+ fellow residents, would lose their homes. Where could they go? With New York facing its greatest shortage of affordable rental housing ever, their only recourse would be to leave the city. Commuting from far away may not be an option for those employed; the move may have to involve working in another city, in another state, in another part of the country. In 2014, snarky critics suggested Iowa as a destination of choice.

What would New York be like without so many health workers? Teacher aids? Shopkeepers? Without the $5.9 billion that NYCHA's $3.4 billion annual expenditures pump into the local economy, and the 16,000 jobs this creates in addition to the NYCHA's own roster of 12,000? Would it become an even more gentrified locale, like San Francisco? Not likely, because the projects would remain. As the foremost historian of New York public housing put it, "The effect that thousands of disordered towers would have in New York is almost beyond imagination."

And what about the country as a whole? As to what a NYCHA failure could mean, another visit to the patch quilt of urban forest and refuse-strewn prairie near the stainless steel arch in St. Louis may hold the answer. If the failure of a single project in the Midwest could trigger a generation-long devaluing of the public sector, what would result from a failure of New York's vast enterprise as a provider of shelter outside the commercial market?

These may be the stakes, then, in the efforts of a couple of hundred brave New Yorkers setting out in the projects each week with cameras.

The neighborhood I am in is so surprising. Anything can happen, good or bad. The sun rises on our faces.

— JARED WELLINGTON

DARREN YANG

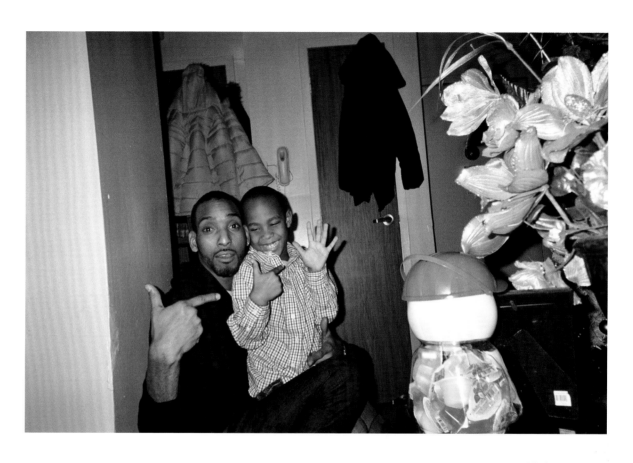

ALICIA MAGAN

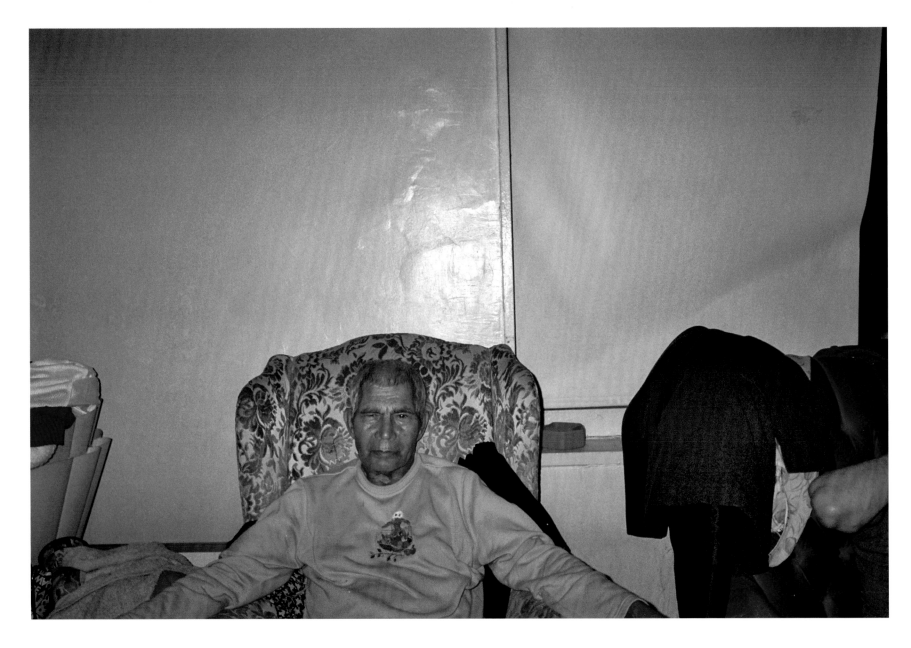

SUSANA ORTIZ

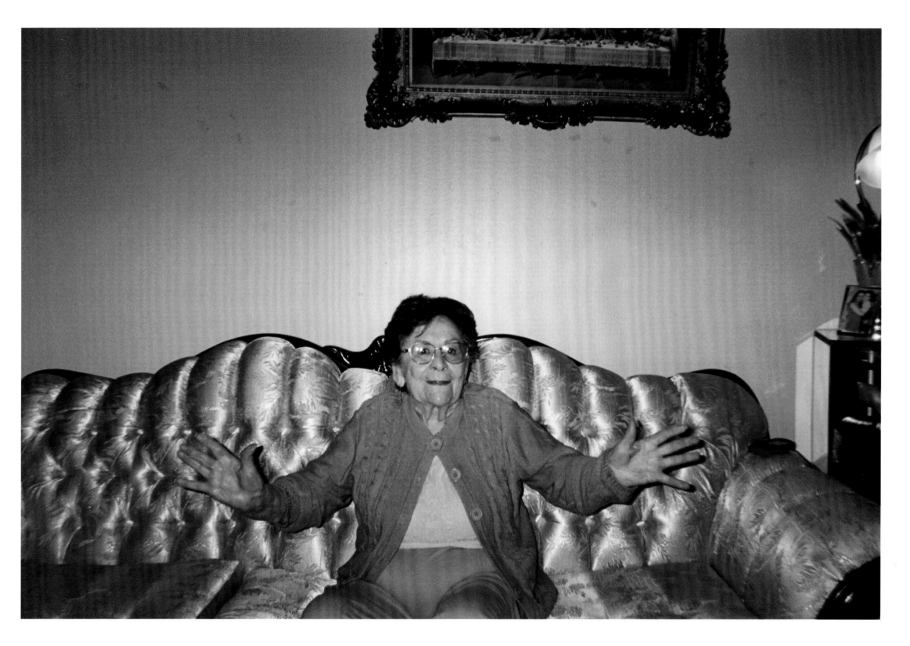

My friend always makes me laugh.

— LINDA ERWIN

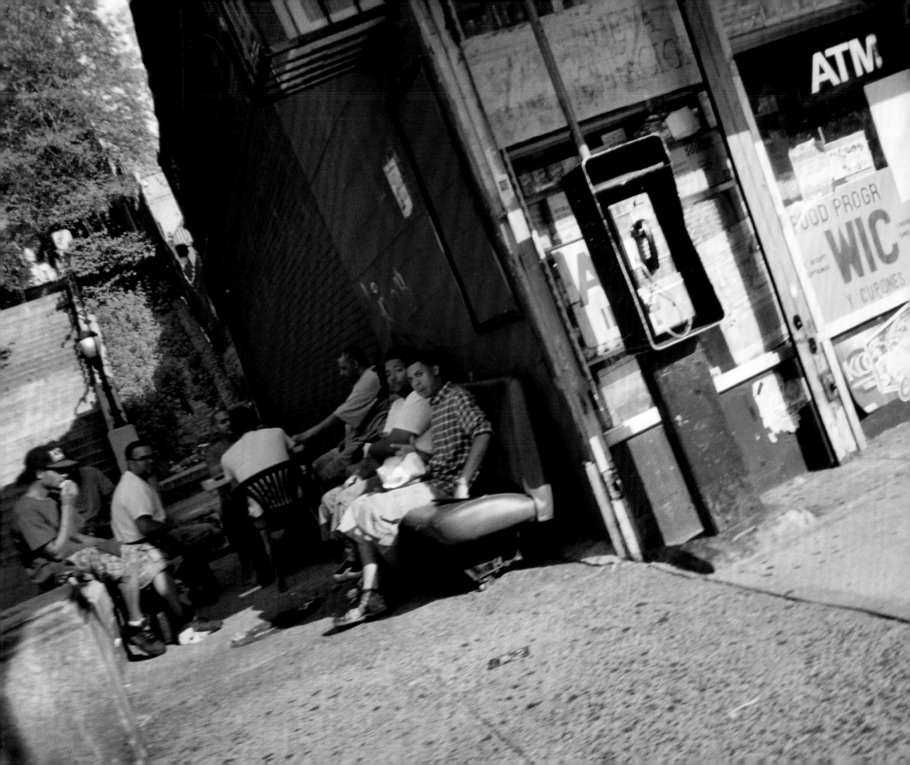

I love my neighborhood because I love going to
the park and I also love my friends here. My mom
sometimes lets me go to my other cousin.
My cousin lives up the hill and I always go.
My dad sometimes buys me whatever I want.

— MOISES JIMINEZ

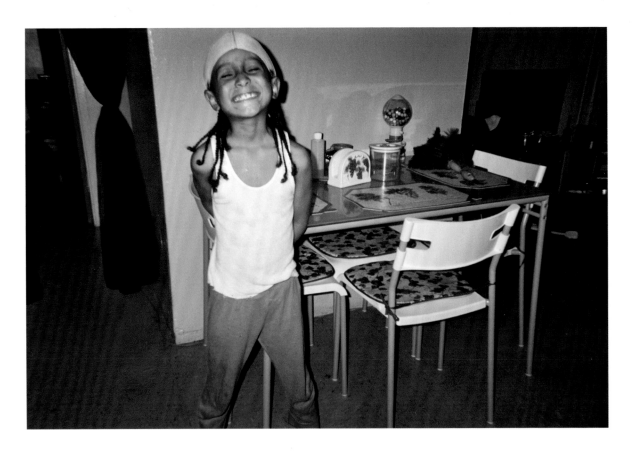

My brother's name is Johnny. He is in my living room and he was getting food from his mother in the kitchen.
The food was chicken, rice, and beans. Sometimes when we get home after going outside we
pick a good book and read about three chapters every day, so by next month we will finish it and start a new book!
Things that make me happy are: my family (mom, dad, brother), my friends, and the things I have in life.

— STARTASIA (STAR) NORRIS

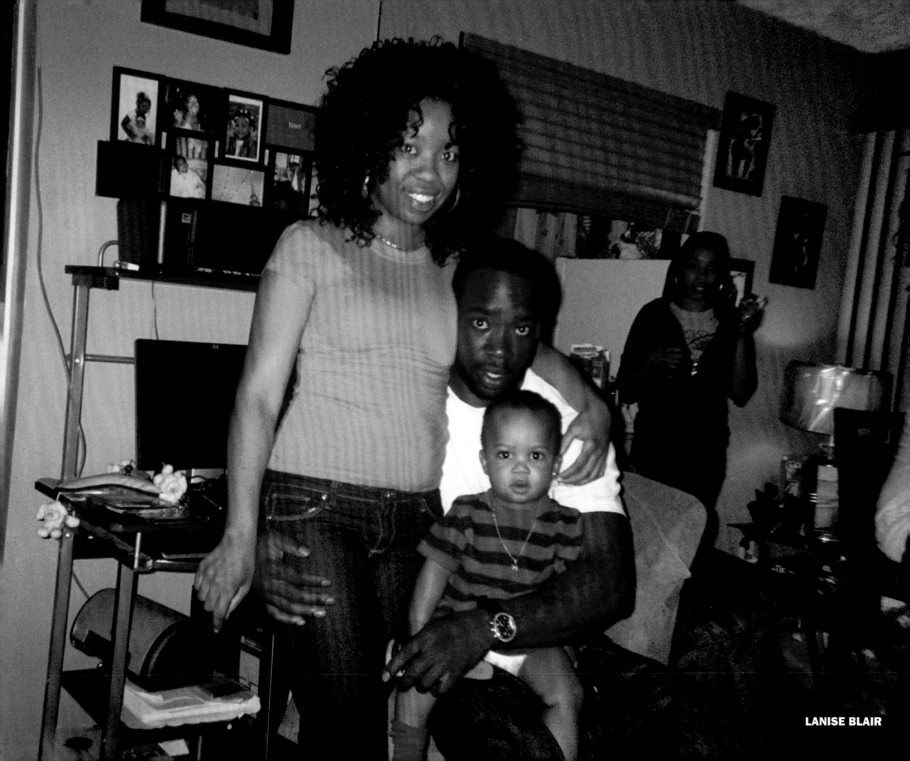

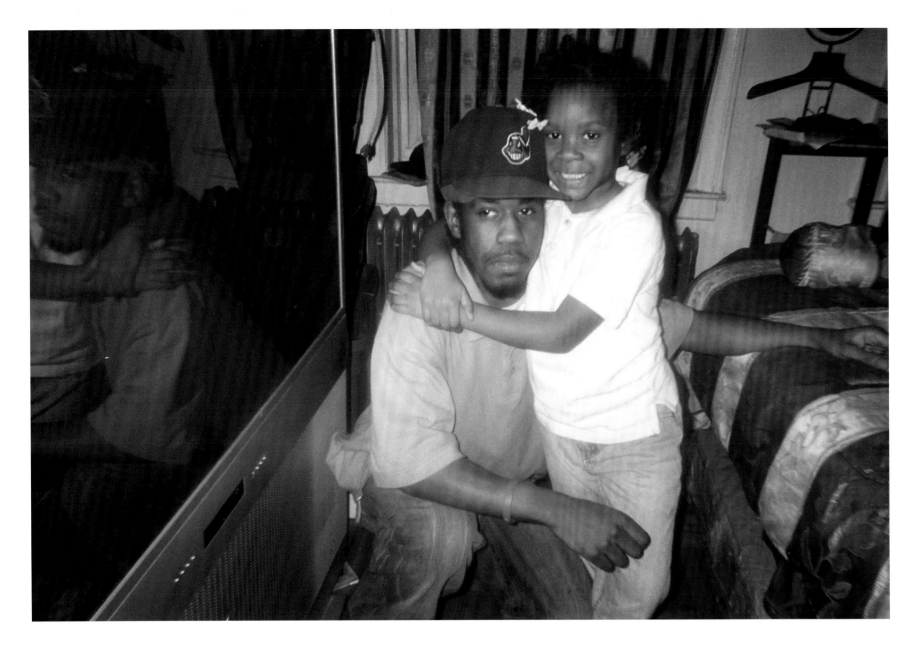

My sister and my step dad make me crack up so hard that I start crying and my ribs hurt.

— AALIYAH COLON

DELVERIN JENKINS

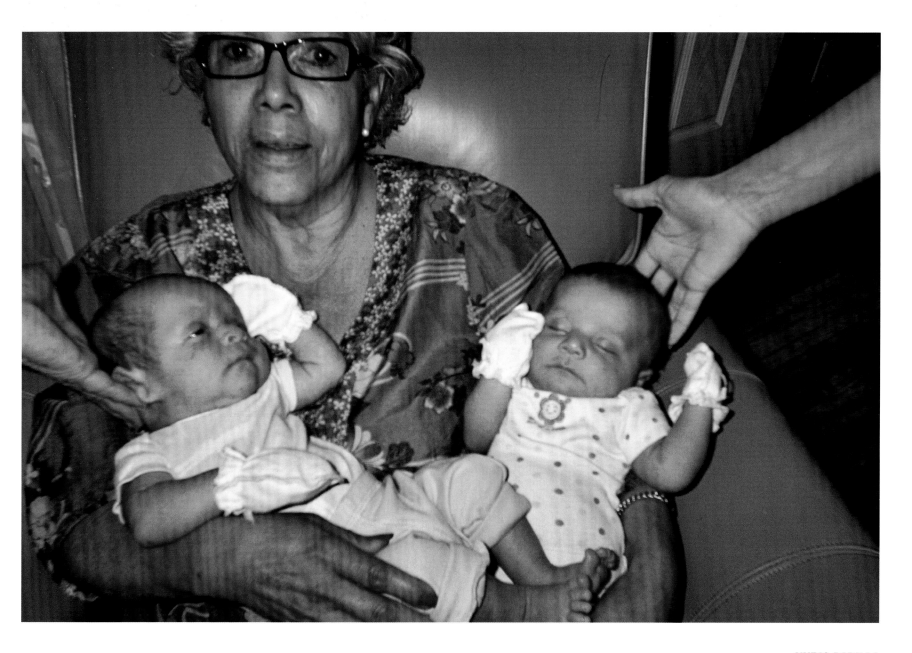

NURIS PADILLA

ANSWERS.

The questions remain.

Are the projects where our photographers live, and the rest of New York's 334 developments, destined to remain Easter Island megaliths populating the city as relics from another New York and a different social contract, as one local journalist scathingly imagined? Or, through the efforts of these intrepid residents, could they again become global symbols of hope and care as they were from, say, 1934–68?

Can the vicious cycle of crime dampening governmental support, leading to further crime and disrepair, discouraging funding once over, finally be broken? Can a virtuous cycle take its place, where a renewed spirit of social concern, assisted by what these pictures reveal about our community, spark more public aid to improve the safety and living conditions of the residents, and lead to even more government funding? Public transportation came back. Could public housing as well?

The answers lie in New York, the city where American public housing began and where the mayoral campaign of 2013 sparked a renewed national concern for inequality. Here, not in St. Louis (whose population could be housed in a vacant Gotham 26 times with room to spare), America will decide how much of a safety net to throw under those who have failed to keep pace with the punishing demands of the real estate market.

We can all acknowledge some truth to the glib retort that New York public housing was never meant to be passed down generation after generation. We can agree that the people who live there arouse the jealousy of a quarter million families idling on the apartment waiting list, also struggling to put a decent roof over their heads. We can recognize that our country, last standing superpower or not, no longer dominates the world economically, with more demands on our dwindling resources than ever before (notwithstanding that less wealthy countries, especially in Scandinavia, manage to take care of

their own). Indeed, we might blanch at the possible tax bill. We can recognize that federal support of local initiatives such as public housing never amounts to a done deal but must be justified anew in every era. And we can acknowledge the open question whether any public agency shortchanged for so long could even properly steward a sudden influx of additional resources. Smarter people than the three of us will need to figure this out.

And paradoxically, while allowing shelter's role in facilitating employment, health, and education, we must finally admit that housing in and of itself can't address all the issues facing the American city. As the shattering 2012 documentary *The Pruitt-Igoe Myth* concluded, there was no way to have built your way out of that tragedy 50 years ago. And with the federal government paralyzed to the point of catatonia in mounting any effective response to burger-slinging as the only reliable job on offer for so many; racial tensions at any moment threatening to descend into a debate on the relative value of white and black lives; and enough drugs coming into the cities to sedate every woman, man, and child many times over, there is no way to maintain enough bricks and mortar to cure today's urban American dilemma.

But still. The hundreds of photographers who participated in Project Lives ventured out there, seeing things for themselves, allowing us to share their vision of community solidarity.

Stranger things have happened than some of our children's children looking back and saluting those who held down the fort until society found the means to restore a priceless refuge for New Yorkers in need. For Americans.

Marcy Morales, Jared Wellington, Gertrude Livingston, Aaliyah Colon, and hundreds of other photographers—Project Lives aims to provide these citizens in society's crosshairs, these real heroes, control of their own image, and a voice.

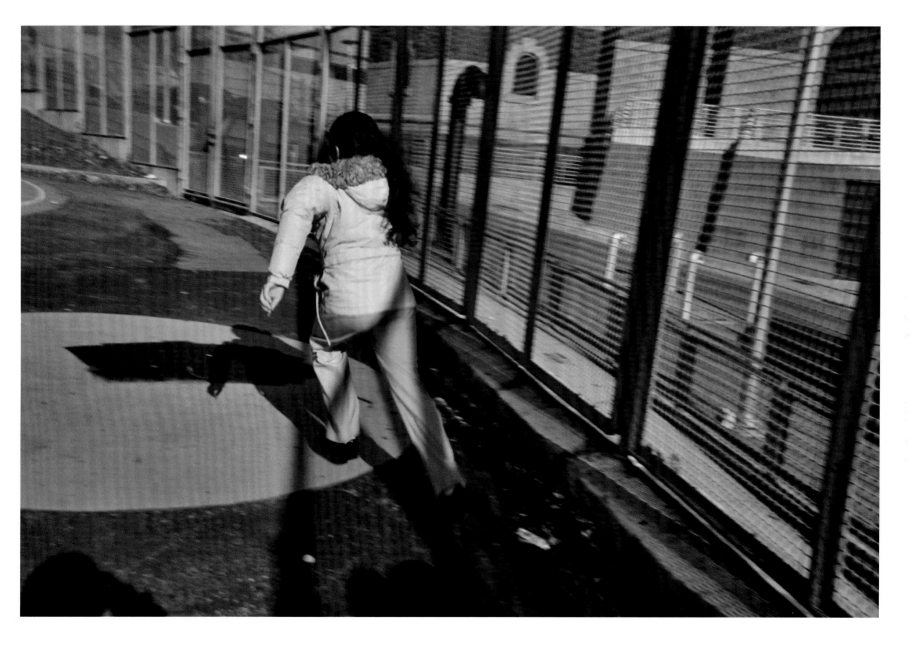

I love how when I'm in the school, hallways are so quiet when I walk through it's just great because you can just hear yourself think about how you are going to plan once you get in class. Just stay focused on what's around you.

— AALIYAH COLON

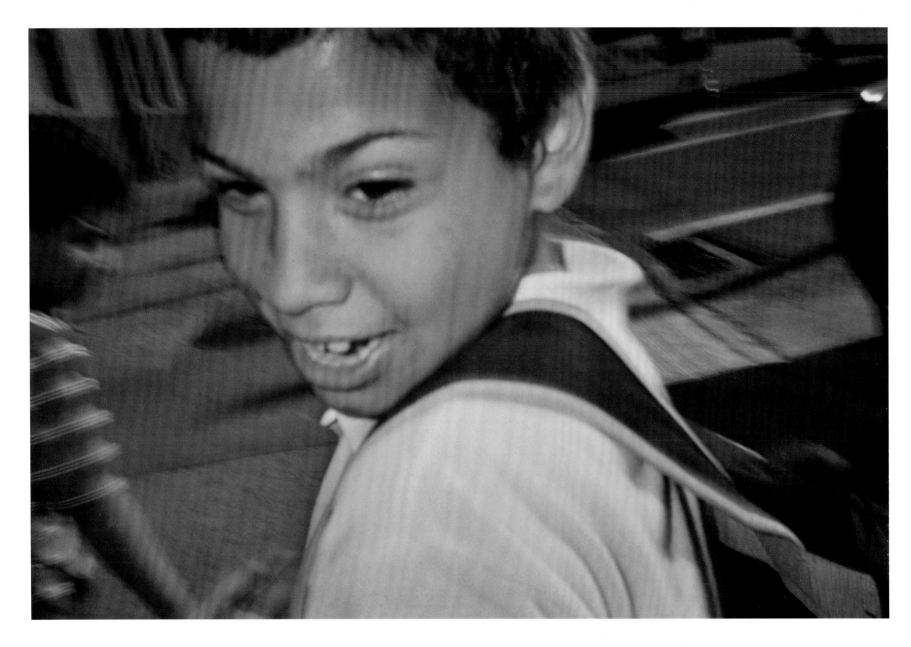

My mom makes me happy because she makes me whatever I want, like rice, beans, and cupcakes.

— MOISES JIMENEZ

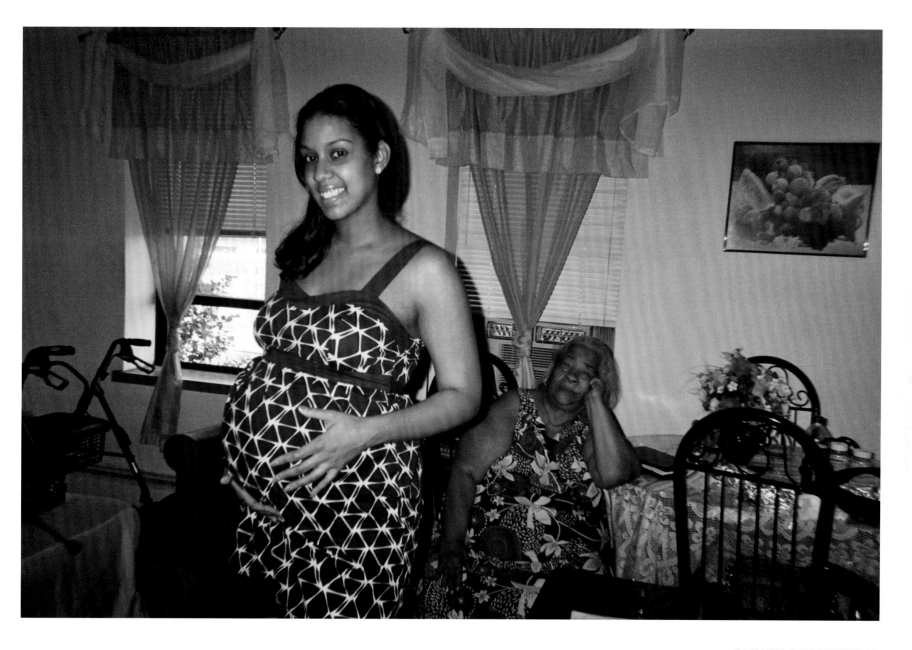

CATALINA (TATA) TRINIDAD

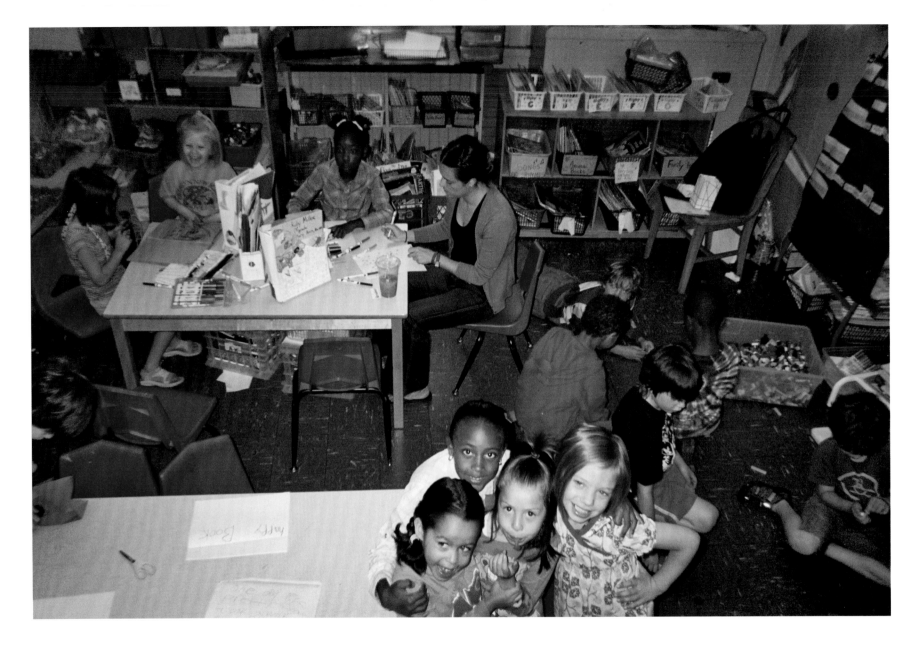

My friends Kaitlyn, Ruby, Luna, and Taylor having "choice time."

— LANISE BLAIR

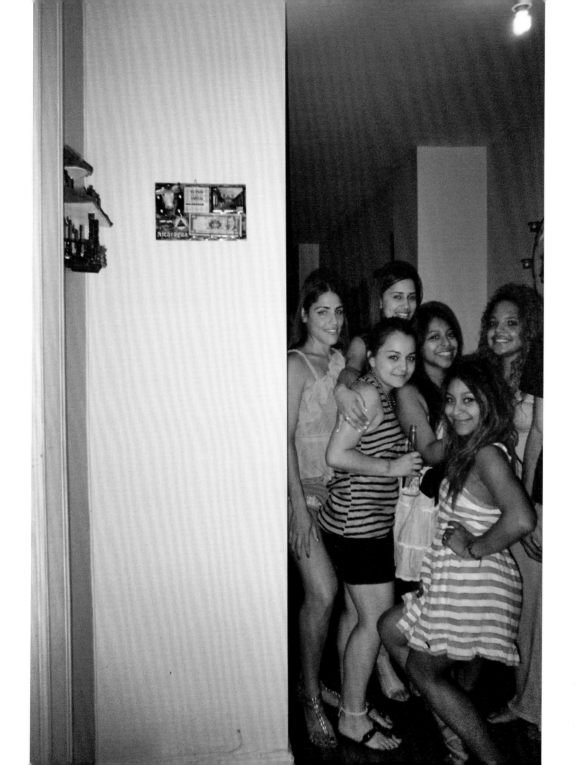

All friends de my nietas.
(All friends of my granddaughter's.)

— ALINA NAVARRO

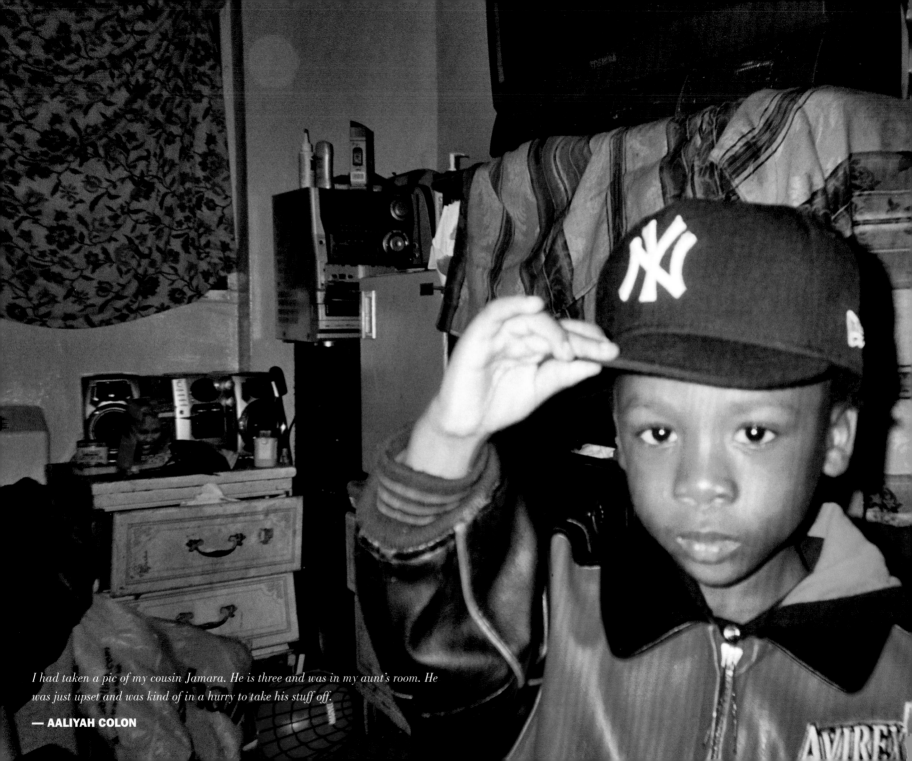

I had taken a pic of my cousin Jamara. He is three and was in my aunt's room. He
was just upset and was kind of in a hurry to take his stuff off.

— AALIYAH COLON

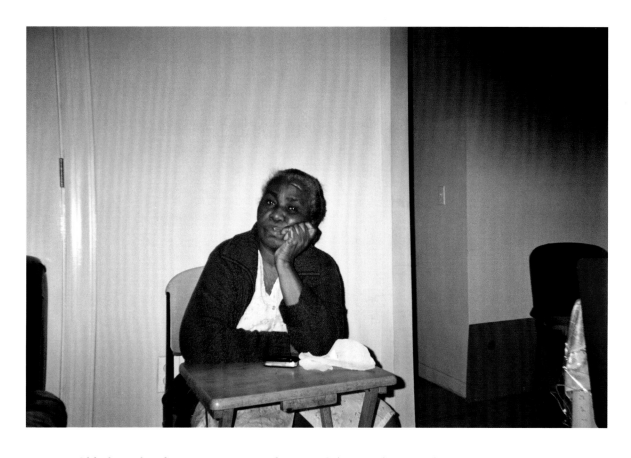

*I like living here because I get my grandma to cook for me. When I stood right near my grandma
while she was looking at basketball she told me, "Pa fe sa tout tan anko sof si mwen gen rad bon pou mwen."
She said, "Don't do that ever again unless I have good clothes on me."*

— ELODIE JEAN-BAPTISTE

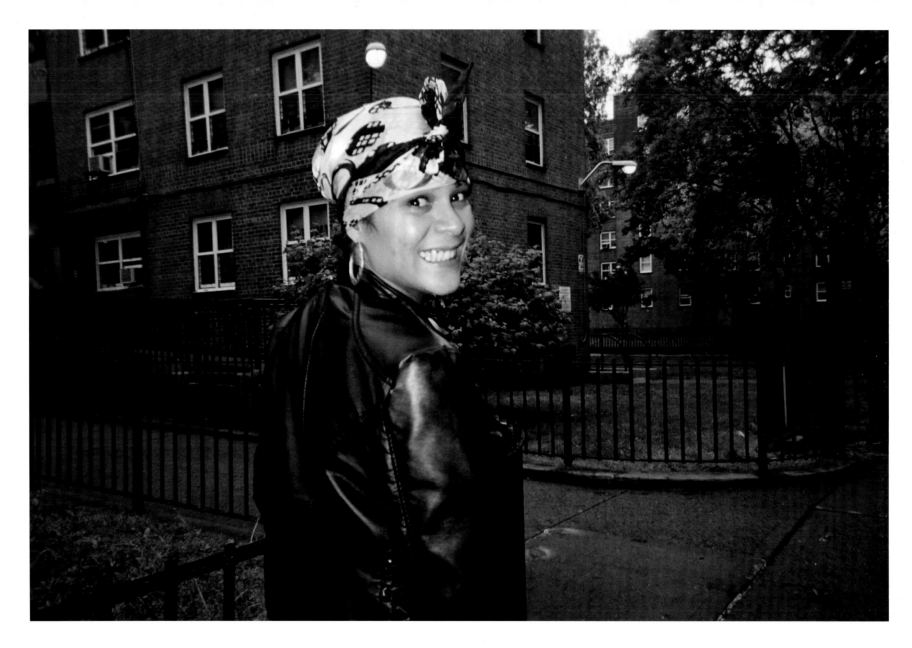

My mom always does the cleaning, washing, and drying. She is the queen of the house. On Saturdays and Sundays we have a family game night and we always count on her to have the games out and the snacks done! The different kinds of games we play are Twister, Sorry, and my mom's favorite game, the Game of Life. When we go to school my mom goes to work. Her job is that she is a security worker in Manhattan by the ferry. When I grow up I want to be a doctor.

— STARTASIA (STAR) NORRIS

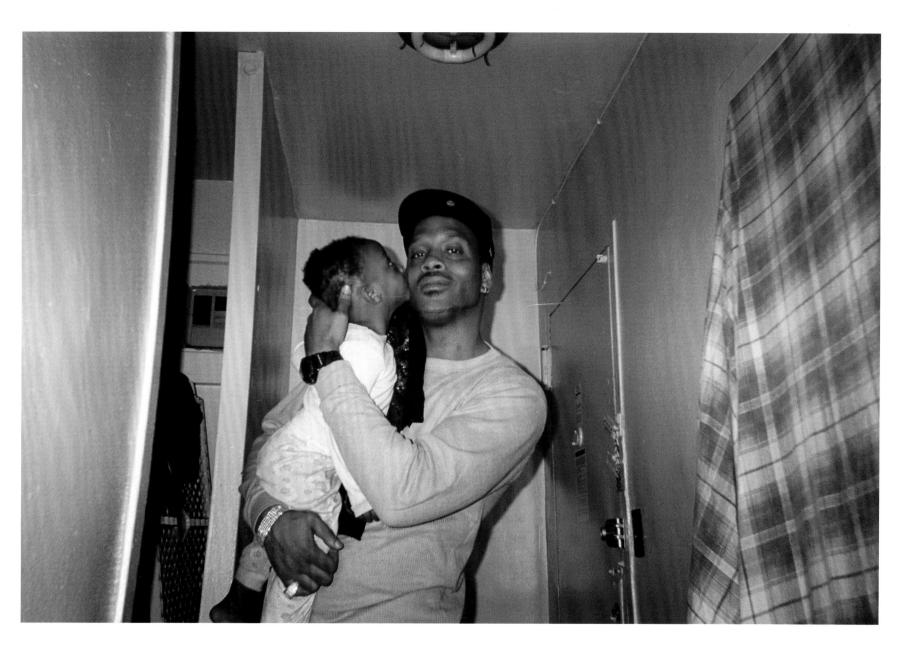

My stepfather said, "Come here Fuss." We call her Fuss because she cries a lot. He said he was trying to look fly.

— JANYIA FORD

GERTRUDE LIVINGSTON

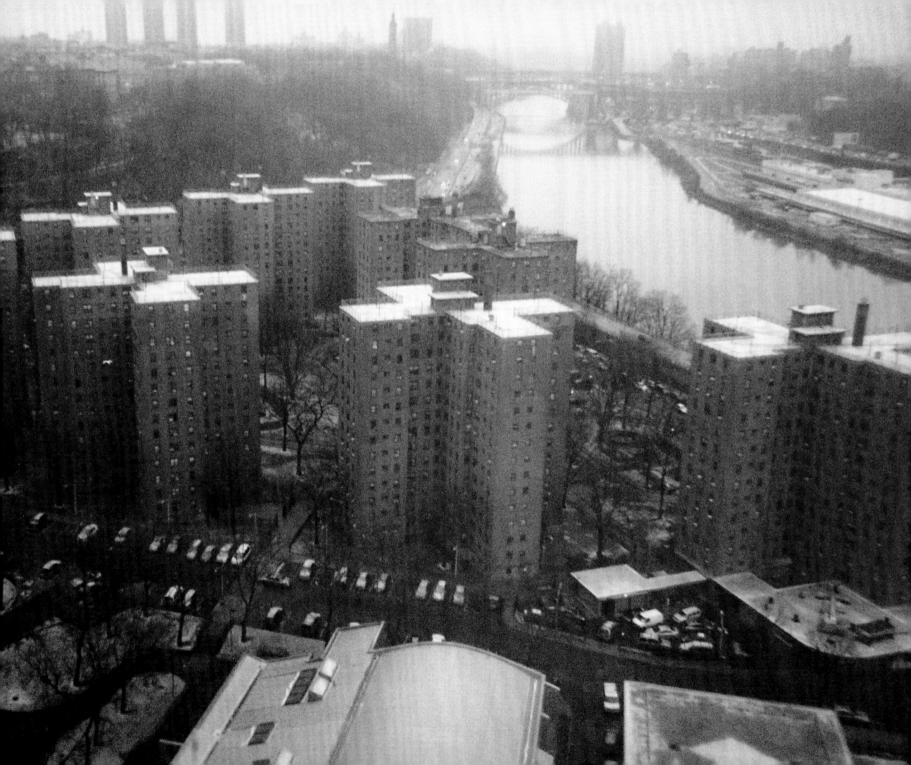

BIBLIOGRAPHY.

Bach, Victor, and Waters, Thomas J. *Strengthening New York City's Public Housing: Directions for Change*. New York, NY. (July 2014).

Baker, Al, "For New York City Officers, Drawing Guns Is Based on Discretion, Not Rules." *The New York Times*. New York, NY. (November 25, 2014).

Barbanel, Josh, "Outside Public Housing, Cameras Abound." *The Wall Street Journal*. New York, NY. (June 4, 2014).

Bloom, Nicholas Dagen. *Public Housing That Worked: New York in the Twentieth Century*. Philadelphia: University of Pennsylvania Press, 2008.

Cowie, Jefferson. *Stayin Alive: The 1970s and the Last Days of the Working Class*. New York: The New Press, 2010.

Davidson, Justin, "This Is a Housing Project." *New York*. New York, NY. (April 7, 2014).

Furman Center for Real Estate and Urban Policy, New York University. *State of New York's Housing and Neighborhoods 2012*. New York, NY. (2012).

Goetz, Edward G. *New Deal Ruins: Race, Economic Justice, and Public Housing Policy*. Ithaca: Cornell University Press, 2013.

Holeywell, Ryan, "Vienna Offers Affordable and Luxurious Housing." *Governing*. Washington DC. (February 2013).

Jacobson, Mark, "The Land That Time and Money Forgot." *New York*. New York, NY. (September 9, 2012).

Joint Center for Housing Studies at Harvard University. *America's Rental Housing: Evolving Markets and Needs*. Cambridge, MA. (December 9, 2013).

Joint Center for Housing Studies at Harvard University. *The State of the Nation's Housing 2013*. Cambridge, MA. (2013).

Konigsberg, Eric, "Woo Cho Bang Bang." *New York*. New York, NY. (June 19, 2014).

Krugman, Paul, "America Goes Dark." *The New York Times*. New York, NY. (August 8, 2010).

MacArthur Foundation. *How Housing Matters Research Briefs*. Web. (April 24, 2014).

Micklethwait, John, and Wooldridge, Adrian, "The State of the State: The Global Contest for the Future of Government." *Foreign Affairs*. New York, NY. (July-August 2014).

Murray, Professor Yxta Maya, "Peering." *Georgetown Journal on Poverty Law & Policy*. Los Angeles, CA. Legal Studies Paper No. 2014-26.

National Low Income Housing Coalition. *Out of Reach 2014: Twenty-Five Years Later, The Affordable Housing Crisis Continues*. Washington D.C. (2014).

Navarro, Mireya, "Public Housing in New York Reaches a Fiscal Crisis." *The New York Times*. New York, NY. (August 11, 2014).

New York City Housing Authority. *Development Data Book* 2013. New York, NY. (2013).

New York City Housing Authority. *Operating & Capital Plans Calendar Years 2014-2018*. New York, NY. (2014).

New York City Housing Authority. *Plan NYCHA*. New York, NY. (December 2011).

Office of the New York City Comptroller Scott M. Springer. *The Growing Gap: New York City's Affordability Challenge*. New York, NY. (2014).

Permanent Citizens Advisory Committee to the MTA. *The Road Back: A Historical Review of the MTA Capital Program*. New York, NY. (May 2012).

Pruitt Igoe Now, "Ideas for an unmentioned landscape." www.pruittigoenow.org. St. Louis, Mo. (2011).

Rahim, Dr. Emad A. "Marginalized through the 'Looking Glass Self': The development of Stereotypes and Labelling." *Journal of International Academic Research*. Aberdeenshire, Scotland, United Kingdom. Vol 10, No 1. (2010).

Schwartz, Alex F. *Housing Policy in the United States*. New York: Routledge, 2010.

Secret, Mosi, "On the Brink in Brownsville." *The New York Times*. New York, NY. (May 1, 2014).

Stiglitz, Joseph. "Phony Capitalism." *Harper's Magazine*. New York, NY. (September 2014).

Stringer, Scott M., Squadron, Daniel, and Kavanagh, Brian. *Protecting NYCHA Communities. New York, NY*. (September 2012).

Tighe, J. Rosie, "Public Opinion and Affordable Housing: A Review of the Literature." *Journal of Planning Literature*. 25.1 (2010). Web. (November 5, 2013).

Umbach, Professor Fritz. *The Last Neighborhood Cops: The Rise and Fall of Community Policing in New York Public Housing*. Princeton: Rutgers University Press, 2011.

Zipp, Samuel. *Manhattan Projects: The Rise and Fall of Urban Renewal in Cold War New York*. New York: Oxford University Press, 2012.

MOVIES.

For the Living. Dir. Clifford Evans, The Television Unit of the City of New York, 1949.

Cooley High. Dir. Michael Schultz, American Independent Pictures, 1975.

Down the Project…From the Project: The Crisis of Public Housing. Dir. Richard Broadman, Documentary Educational Resources, 1982.

Candyman. Dir. Bernard Rose, Polygram Filmed Entertainment et. al., 1992.

Public Housing. Dir. Frederick Wiseman, Zipporah Films, 1997.

Legacy. Dir. Tod Lending, Nomadic Pictures, 1999.

Brooklyn Bound. Dir. Richie Devaney, Mean Pictures et. al., 2004.

American Gangster. Dir. Ridley Scott, Universal Pictures, 2007.

Precious. Dir. Lee Daniels, Lionsgate, 2009.

Harry Brown. Dir. Daniel Barber, Marv Films et. al., 2009.

Brooklyn's Finest. Dir. Antoine Fuqua, Millenium Films, 2010.

Son of No One. Dir. Dito Montiel, Anchor Bay Entertainment, 2011.

Player Hating: A Love Story. Dir. Maggie Hadleigh-West, Film Fatale, 2012.

The Pruitt-Igoe Myth. Dir. Chad Freidrichs, First Run Features, 2012.

Red Hook Summer. Dir. Spike Lee, 40 Acres and a Mule Filmworks, 2012.

Broken City. Dir. Allen Hughes, New Regency, 2013.

The Inevitable Defeat of Mister & Pete. Dir. George Tillman, Jr., Lionsgate, 2013.

PHOTO CREDITS.

Project Lives:
New York Public Housing Residents Photograph Their World

Compilation & editing © 2015 George Carrano, Chelsea Davis,
and Jonathan Fisher

Text © 2015 George Carrano and Jonathan Fisher

Published in the United States by powerHouse Books,
a division of powerHouse Cultural Entertainment, Inc.
37 Main Street, Brooklyn, NY 11201-1021
telephone 212.604.9074, fax 212.366.5247
e-mail: info@powerHouseBooks.com
website: www.powerHouseBooks.com

First edition, 2015

Library of Congress Control Number: 2014957185

ISBN 978-1-57687-737-1

Design by Bonnie Briant Design, Brooklyn, NY

Printed and bound through Asia Pacific Offset

10 9 8 7 6 5 4 3 2 1

Printed and bound in China